Remote Control

Barbara Kruger

Remote Control

Power,

Cultures,

and the

World of

Appearances

The MIT Press Cambridge, Massachusetts London, England

Second printing, 1994
©1993 Barbara Kruger

This book was set in Bembo by .eps Electronic Publishing Services and was
printed and bound in the United States of America.

Library of Congress Cataloging-in-Publication Data

Kruger, Barbara, 1945–
 Remote control : power, cultures, and the world of appearances / Barbara
Kruger.
 p. cm.
 Includes index.
 ISBN 0-262-11177-2
 1. Arts, American. 2. Arts, Modern—20th century—United States.
I. Title.
NX504.K77 1993

700'.973'09048—dc20 93-18217
 CIP

Contents

Arts and Leisures

Arts and Leisures

There's something about categorizing things, about putting things in their place. Maybe it's about a kind of comfort. Maybe it's about setting things straight, putting first things first. Whatever it is, it surely has a hold on us. We seem intent on labeling and ordering. It's how we get on with our lives, how we proceed. It's all in a day's work: from the maintenance of homes and offices to the supposedly loftier pursuits of arranging history and conducting diplomacy. These orderings try to make sense of a complex world, easing us into understanding but also showing us what to know and how to know it. And like just about everything else under the sun, they are drenched in taste: that non-stop dictation of the loved and the unloved, the coveted and the passé. Of course, there are lots of different kinds of ordering. There's the regimentation of the military, the labyrinths of libraries, the paradigms of science, and the style of wars of the arts, to name just a few. In fact, museums are categorizing exhibitionists, boldly flashing their ordering compulsions with a kind of decorous abandon.

Likewise, the very newspaper which you are now reading is an amalgam of categories. Aside from global, national, and metropolitan news, there's sports, science, living, etc. Sunday, this bulky behemoth you are now perusing, is the embrace of it all, a week's worth of reportage, of attentions given and judgments passed. And since you are now loitering around this

particular section, it should be obvious that there's art and there's leisure.

This last coupling is an oldie but goody that neatly perpetuates the conventional gap between the fine arts and so-called popular culture. Okay, let's turn the pages and try to figure out which is art and which is leisure. Or, in other words, what is "high" and what is "low." Let's see. Art is obviously art, right? And sometimes theater is art, but sometimes it's just a lot of escapist hullabaloo, right? Dance is art. TV and movies are leisure, I guess. But what about "the cinema," that high-toned and serious activity? Pop has got to be leisure. Recordings can be art in their inception and leisure in their reception. Music is a little bit of both, depending on the music. Antiques can be either art or pop in their creation, but their collection is highly serious leisure. And where does architecture fit in, with its careful collapse of form into function?

In fact, architectural discourse spawned one of the most recently cited categories: that vaporous buzzword, that zany genre with legs: post-modernism. But what does this term, inflated into a ridiculous journalistic convenience, actually mean? To some it's an excuse to pile together oodles of wild and crazy decor, to others it's another example of the weakening of standards and values, to others a transgressive resistance to the sureness of categories, to others a handy way to describe a particular house, dress, car, artist, dessert, or pet, and to others it's simply already *over*. But aside from all these possible meanings, it's the prefix itself which is problematic. All "post"'s seem to declare particular genres or periods over and done, and this

kind of closure is troubling. If you think in terms of continuums rather than encapsulations, if you note the power of historic processes rather than that of fixed objects or groupings, this declaration of finality is strangely suspect. (The most egregious example of this usage is the journalistically touted "post-feminism" which emerged, not coincidentally, just as the conventional relations between gender and power entered a period of crisis.) So, if the term "post-modernism" *has* to be used, it would be nice if it could question the sanctity of categories themselves: playing fast and loose with their seriousness, spreading their wealth, welcoming compelling multiplicities and inclusions rather than singular "great" achievements.

But wait a minute! What's the matter with great achievements? And what about values and standards? Is that the muttering I hear in the wings? Isn't it a bit foolhardy to propose an end to the structures that really matter? Matter to whom, I ask. Are these values and standards dollops of divine rule that have wafted down to earth? Or are they simply the pleasures and preferences of those who archivize, hierarchize, and capitalize; who construct cultural history through their admittances and exclusions. And technology, that relentless magic show, has changed our lives while both enlarging and shrinking the cultural field. It is now obvious that segments of society are not discrete categories, but rather simultaneous processes that collide, seep, and withdraw with, into, and from one another. Seeing is no longer believing. The very notion of truth has been put into crisis. In a world bloated with images, we are finally learning that photographs do indeed lie. In a society rife with purported information, we know that words have power, but

usually when they don't mean anything (as Peggy Noonan and Co. have so ably demonstrated). This concerted attempt to erase the responsibilities of thought and volition from our daily lives has produced a nation of couched-out soft touches, easily riled up by the most cynically vacuous sloganeering and handily manipulated by the alibis of "morality" and false patriotism. To put it bluntly, no one's home. We are literally absent from our own present. We are elsewhere, not in the real but in the represented. Our bodies, the flesh and blood of it all, have given way to representations: figures that cavort on TV, movie, and computer screens. Propped up and ultra-relaxed, we teeter on the cusp of narcolepsy and believe everything and nothing.

Now in the short run, none of this might feel too bad. It's groggily comfy and when it hurts, it hurts so good. But to those who work with numbers, we are literally on the money, as polling has become the measure of us; the way we are made to count or not. And to those who understand how pictures and words shape consensus, we are unmoving targets waiting to be turned on and off by the relentless seductions of remote control. We are demi-living proof that the video camera has replaced the mirror as the reflection of choice.

So what does all this mean and what can be done about it? If we experience life *only* through the filters of rigid categorizations, and binary oppositions, things will definitely be business as usual. Good will battle evil. Objectivity will be enthroned and "politics" suspect. Art will be high and popular culture low. But what do these terms mean? How can we begin to question these stereotypes of heroism and villainy? And what is objectivity, that wild and crazy, value-free site located no-

where near opinions and desires? And isn't it time we realized that there's a politic in every conversation we have, every deal we make, every face we kiss? And what about art? It can be defined as the ability, through visual, verbal, gestural, and musical means, to objectify one's experience of the world: to show and tell, through a kind of eloquent shorthand, how it feels to be alive. And of course a work of art can also be a potential commodity, a vessel of financial speculation and exchange.

But doesn't so-called popular culture have the ability to do some of the same things: to encapsulate in a gesture, a laugh, a terrific melodic hook, a powerful narrative, the same tenuously evocative moments, the same fugitive visions? Does a spot in a museum's chorus line of wall trophies guarantee an experience of art that an urgently pleasurable piece of pop music can't aspire to? What about the witty eloquence of urban Afro-American dance, the brilliant nuances of Tracey Ullman's and Sandra Bernhard's comedic characterizations, and Queen Latifah, Salt-n-Pepa, Yo-Yo, and other much awaited female rappers telling it like it *really* is? Aren't these eloquently drawn pictures of some of our lives? And have there been more incisive refutations of the deluded fantasies that pass for family life than the intensely negative (that's "bad" as in good) depictions of Tim Hunter's film *River's Edge,* Sam Fuller's *Naked Kiss,* Spike Lee's *Jungle Fever,* or Matt Groening's TV *Simpsons?*

Clearly, "art" is still primarily a cottage industry. As opposed to most architectural, film, and TV works, which need constant infusions of client capital to happen, "art" (up until now at least) can remain relatively unmediated by the armies of "collaborators" whose desires must be considered and wallets

stroked. But against all odds and in spite of the dumb conventions and convoluted corporate power trips that give "popular" culture its numbing effect, a few works of intensely compelling clarity do manage to emerge.

Times have changed and the world comes to us in different ways. Narrative has leaped from the page to the screen, music demands to be seen as well as heard, computers have jumbled our relationship to information, surveillance, and money, and television has merely changed *everything*. Now things feel like they're moving *really* fast, leaving us with the attention spans of kitties riveted by mouse-like movements. With the blink of a blind eye, we are soaked in sales pitches and infotainments that make history when they do business.

Running in place at the speed of light, we defensively cling to our unexamined notion of categories, our dilapidated signposts in a bleak landscape. They make things simple again. Reflections of control, they reassure us that there's a time and a place for everything. Declaring what's right and wrong, they can strengthen stereotypes and murmur the false humilities of "common sense." Glowing with a veneer of studied connoisseurship, they can grow nostalgic over times that never were. They are easy systems. Use them but doubt them. They are the rules of the game, but perhaps no longer the one being played.

1990

Quality

Quality. The dictionary gives us at least two takes on the word. One, mainly categorical and scientistic, the other more rife with desire, that is judgment. First we are told that quality is that which distinguishes one person or thing from others. It is an attribute, a characteristic, a trait. But on the other hand, in the hand of desire, it becomes a degree of excellence and superiority. It is said to have distinction, stature, and dignity. Now it's obvious that although the classifying usage of quality is well exercised, it is its judgmental function that motors its power. Now I must admit that discussions about quality are not exactly what's been on the tip of my tongue of late. And while it may be true that the upsides and downsides of quality might be a hot topic in the so-called "art world," I'd prefer not to focus on quality as an exclusively esthetic determinant, but rather as a broader indicator of the power of taste: a discourse that instructs not only what we put in our mouths, but how we put ourselves together, how we furnish our bodies, our homes, our governments, our museums, and our minds.

Taste literally dictates the techniques of our bodies. It is a social orientation that shows us our place in the world. What we love, what we hate, what "works" for us, is inevitably a combo of where we've come from, and where we think we're going. Taste is not an object, but a process: a series of framings and refinements which lead to one's particular image of perfection. And because everything is, to some degree, subsumed by

fashion, even our images of perfection are up for grabs, chang-ing constantly, mutating from one hotness to another. Quality might be said to be the end product of the process of taste: the essence that's left after the acid test: the nectar of resolution that becomes "exemplary."

But this quest for perfection is never singular. It's plural, relentless, and fickle: a battle fought on a million fronts a min-ute. As soon as one jewel is discovered, we fall to the thrall of another. The process never ends, leaving in its wake a glorious graveyard of gorgeousness: profundities that litter the cultural landscape like a kind of creative compost heap which could be called art history, or cultural history.

But this perfection, this "specialness," this quality, can ob-viously be many things to many people. What others have called "esthetic emotion" strikes a match in me. But I'd relieve the phrase of its formal attire and speak of it as a kind of "felt" moment, a visual resonance, or maybe a showing and telling it like it is. It might be the perfection of different kinds of spec-tators, making different meanings and drawing different conclu-sions. It might be the frenzy of the visible or the discretion of the almost absent. It might be the asking of questions rather than the dictation of answers, or both. It might even be a kind of esthetic emotion that suggests that empathy can change the world. It might be called an esthetic of qualities rather than the singularity of quality. I think I could go for that esthetic. I think I could second that emotion.

But how do these moments of esthetic emotion, these perfections, these qualities, accumulate into a cultural history? And isn't history itself non-singular? Isn't it a multitude that

exists as a chorus of recordings and reckonings which broadcast their findings with differing resonance and success? Some become dominant, become the rules of the game, the way it was and is: while others fade, become dominated, obscure bits of marginalia. One is "major," "significant," and "great," the others second-rate, insignificant, failed. One wins, the others lose.

But likewise, should we infer from this that all that win, all that "really matter," the consensus images of perfection, are inevitably evil and spurious and that all that lose are righteous, better, and on the side of the angels? Let me suggest a breakdown of the binaryness of this equation, away from the sureness of bad versus goodisms, of moral highgrounds and evil empires, into an aerosol of powers and possibilities. Perhaps now is the time to consider how power manifests itself in judgment and in the doubtless candor of criteria and taste. How power can dissemble and invert lived experience, how it appropriates slogans, struggles, and bodies, how it mouths the false humilities of common sense, and how (as we are now seeing) its fear of change can detonate torrents of vindictiveness and victim-blaming.

Because of this, perhaps now is the time to practice a kind of generosity, a spirited inclusiveness which welcomes in sights and sounds which have been unseen and unheard of: to trade fear for an embrace, and to realize that to abuse power you first must have it. And those who have had it must know who they are. But those who have been largely excluded from power are also vulnerable to the inducements of its siren song, of its excesses and abuses. So the idea is not to replace one hero with another, one quality with another, one canon with another, one

hierarchy with another: but to attempt a critique which is sys-
temic rather than substitutional, which questions the methods
of our madness and is interested a little less in the singer and a
little more in the song. Perhaps we must remain perpetually
vigilant in guarding against becoming what we fear. Perhaps we
must first work to recognize the full breadth and depth of our
cultural qualities and only *then* begin the stringent framings of
our taste, the anointed namings of our judgments, and the moist
choices of our desires.

1991

Remaking History
written with Philomena Mariani

The Questions: What administers the souls of the dead? What is the euphoria of the panorama? What is the neatly voluptuous plenitude which, arranging sequences and ordering events, locks in the world? What revels in the site of the so-called objective with the abandon usually reserved for the body, but has no body? The Answer: History. There is only one answer because there has purportedly been only one history: a bulky encapsulation of singularity, a univocal voice-over, an instructor of origin, power, and mastery. History has been the text of the dead dictated to the living, through a voice which cannot speak for itself. The ventriloquist that balances corpses on its knee, that gives speech to silence, and transforms bones and blood into reminiscences, is none other than the historian. The keeper of the text. The teller of the story. The worker of mute mouths.

But what happens if the answer to the preceding questions is not a singular response which is "history," but a chorus of commentaries, a crowd of reckonings. What might be attempted is this: a display of expository moments and happenings which tell not only of events and proper names, but of their places within a broader construct of forces and relations. What happens when the formalities and franchises of "history" are displaced into a dispersal of stories? Who has stories to tell? What are their methodologies? How do they speak to their readers? What are the tones of their voices?

If traditional history writing has been in a sense a process of collecting, it has also been a process of marginalizing, omitting. Still, it speaks *at* us, if not *to* us, with the authority of all discourses that seek to demonstrate cause-and-effect. The past several years have seen the development of alternate histories, recoveries of neglected and "forgotten" cultures and the recuperation of names and faces. Simultaneous with the elaboration of critical theories problematizing the construction of the subject and the relationship between knowledge and power, this process of recovery has been essential to challenging masculinist and Eurocentric visions that rely on linear narrative and promote totalizing concepts. The foundation of traditional historiography, the *document,* has now become one discursive text among many, and which ones the historian chooses for his or her analysis becomes a crucial issue in itself, bringing into focus such questions as race, gender, class, and institutional affiliation. The awareness of the voices of "others," the plurality of stories to tell, has produced, as Foucault describes it, a "new form of history [that] is trying to develop its own theory" and one in which one works "to specify the . . . concepts that enable us to conceive of *discontinuity.*" And, one might add, difference.

The new historicism is not necessarily a History of the Victors. It disrupts the notion of the "major" event. It is anti-hierarchical and questions the narratives of chronology. It is cross-disciplinary: its most productive tools of analysis are originating in feminist literary-critical studies and in their rereadings of psychoanalytic texts; in post-structural, sociolinguistic examinations of ideology construction and its operation through the

political, cultural, and social; out of cultural studies from the perspective of race and experiences of exclusion; and out of a recognition of the power of the image, its centrality in ideological formations and its usefulness in analyzing change and reformation.

Official History, increasingly made for TV, becomes indisputable fact through its repetitions and powerful alignments. One site of struggle against this imperialism that colonizes bodies and minds centers on the text. Texts empower; they grant authority, and their deconstruction from race-gender perspectives had become a kind of anti-imperialist strategy that has reverberations for political action.

This work is ongoing and urgent. The confusion of discourses generated by the publication of Salman Rushdie's *Satanic Verses* is paradigmatic: a "fiction" that includes a critique of Islam is published in the West where racist attitudes toward Iranians have been promoted and utilized with great profit over the past decade. This text provokes violent threats to the author from a religious counter-revolution that cannot bear to be criticized. This text generates a spectrum of corroborations and dissenting opinions from Muslims worldwide. This text is presumably responsible for generating bloodshed that threatens the stability of the regime of a female president of a Muslim country (who, coincidentally, was the subject of one of the author's previous books), that simultaneously, then, raises issues about Islamic attitudes toward women and the complicated conflation of Western feminism and education with imperialism. This text becomes the focus of nightly news accounts as a struggle between liberalism and fundamentalism and their respective stands

on "personal freedom," "individualism," etc., which leaves little room for discussion of other possible social orders. Conventional methods of historical analysis—which create polarities or tend to choose the most "dramatic" moment or end in the typical trajectory of linearity—cannot excavate and disentangle all the voices in this complicated text.

Which has been and continues to be the motivation behind much of the new historical writing: to allow the chorus of voices to speak, to focus on the process and not just the moment, on the scene and not just the individual, on the body and not just the figure. The new history is not only about the pain of the past, or the struggles of the present, but implicitly and explicitly proposes inclusive definitions for democratic futures.

1989

An "Unsightly" Site

A city like New York can be seen as a dense cluster of civilization: a rampant bundle of comings and goings veneered with the tumultuous urgency of people busy living and dying. Amidst all this, Times Square has existed as a kind of brazenly pumped-up light show, a mix of touristic travel and insistent loitering. But now something new is emerging, a different face for Times Square: a makeover of sorts, resulting from an explosion of office construction on Manhattan's West Side. It should come as no surprise that this mandate for change comes now, for it can be seen as a reflection of the incremental alterations which have transformed Manhattan from a cluster of varietal neighborhoods to a vertical ladder of economic imperative: the stairway to heaven, the top of the charts, the lifestyle of the rich and sometimes famous. The problem posed: how to make Times Square safe for corporate capital, how to most efficiently erase the area's explicit sexualities and forthright mixing of black and white, poverty and big bucks, homeless New Yorkers and wide-eyed tourists, the Broadway *theatuh* and the choreographies of the street. If left to their own devices (which they almost always are), there's no doubt that the powers that be would handily convert Times Square into another tired stretch of boring behemoths which, bereft of advertising and commerce, would transform streetlevel (in the style of Park Avenue and the Avenue of the Americas) into merely another arid alley separating one CEO from another.

Fortunately, other voices have interrupted the dismantling of the area's well-framed and decoratively declarative sales pitchery. In 1984, The Municipal Art Society launched a campaign to "Keep Times Square Alive" which, along with the "Save Our Theaters" group, succeeded in winning a number of concessions limiting the complete decimation of the area. Foregrounding the neighborhood's importance as an Entertainment district, they pushed for the continuance of blatant advertising, illuminated signage, and semi-baudy indulgence. In order for this to occur, however, the architecture of the planned office blocs would have to be altered, allowing for a slight down-zoning and set-backs which would create areas in which to display outsize graphics and super signs. This would help maintain the Square's feeling of an outdoor room which, historically, has always blended the pleasure of great dreams with the stuff of nightmares. And aptly so, as it was named after the newspaper which you are now reading.

The well-memorized Times Square was a high-voltaged spectacle which charmed its viewers with ridiculous suppositions made real: giant men blowing smoke rings, waterfalls traipsing along the tops of buildings, the A&P coffee sign which emitted the aroma of a fresh-brewed cup, the fifty-feet-high neon Miss Youthform who towered over us clad in nothing but a slip, and my fave, the Kleenex sign which announced that "You Can Blow Your Head Off." Times Square was, and could again be, this kind of gargantuan yet contained spectacle that perpetually flirts with our senses of wonderment and pleasure.

But make no mistake about it, all this wonderment and pleasure would co-exist alongside far more brutal conditions:

reminders of the severe cultural ruptures which smash poverty and the half-life of drugs against the brittle display windows of glamourous expenditure. In other words, the "reclamation" of Times Square, while relieving the area of some of its most apparent difficulties, is engaged in the militant removal of all that is "unsightly," sweeping out of sight and under the rug the complex problems of an intense urban culture showered with both extraordinarily lustrous wealth *and* systemic poverty and disease. But is it possible to complain about the SRO's that dot the area without seeing them as reminders of local government's inability to help provide shelter for any but the wealthiest New Yorkers? Is it possible to grimace at urban poverty and drugs without considering the Reagan/Bush administration's staunch commitment to "its own" while patiently waiting for all those yuckky "others" to simply starve or expire through disease? For the past decade we have watched the Federal government refine its policy of callous anti-urban bias, which is incrementally destroying the viability of American cities. This intolerance and unapologetic racism is rivaled only by its cynical erasure of almost any productive domestic or economic policies for the nation.

Despite all of this, cities remain national treasures: sites of forced proximity and edgy experiments in density and inclusion. But as the Federal government's reactionary entrenchment has shown us, they are also threats to power and conventional notions of control. Surely, Times Square could again function as a fabulous diamond in a great setting. Surely, it could sport outrageously intrusive graphics adorning generously user-friendly buildings: literally the flip side of Park Avenue drab.

Surely, it could spare us the feel of a corporatized ghost town, a city with no there there, a town without pity. But, of course, all the smoke and mirrors in the world can't dim the harsh realities facing us in this time of AIDS, urban crisis, and collapsing infra-structures. Nevertheless, the time is now for cities to speak out and act up: to suggest concise and generative rethinkings of what urban life can mean in a changing America. And to understand that the kind of spectacle that Times Square makes of itself is, indeed, a sign of the times.

1988

Contempt and Adoration

The most beautiful thing in Tokyo is McDonald's.
The most beautiful thing in Stockholm is McDonald's.
The most beautiful thing in Florence is McDonald's.
Peking and Moscow don't have anything beautiful yet.
—Andy Warhol, *The Philosophy of Andy Warhol,* 1975

Aside from serving food relatively quickly, McDonald's is about a particular kind of presentation: the American rendition. It condenses the look of the last 35 years of highway architecture and public eateries into the time it takes to grab a bite. Above all, it is the primary vision of businessmen concerned with profit and efficiency in the field of food services. But McD's brand of global culinary imperialism and the brass-tackism of its financial acumen was of little concern to Andy Warhol, to whom McDonald's was both merely, and most importantly, beautiful. He might have also called it adorable: as in showered with fun and crowned in cuteness. His comment can read as a happily relieved relinquishment of the critical, a resolutely numbed-out dose of enthrallment. But maybe it can also work as a dislocator, courting the negative with a kind of languid irony. Andy Warhol always seemed to hanker for that really pretty line that wandered unmerrily between contempt and adoration.

The adoration was the easy part, like the icy vehemence of the kind of guy who would stand outside the Pantages Theater on Oscar night, clutching a bouquet of roses for one star or

another. For the guy who wanted to be reincarnated as a diamond on Liz Taylor's finger, proximity to fame was almost enough: a sort of elixir, an enabling connection plugging him into the glittering dispensations of prominence. His own celebrity became part of a baroque networking, a bright constellation of havers and doers who could inhabit the VIP lounge of the universe, where everybody who was anybody would show that they could never be mistaken for a nobody.

All these yens for glamour and fame, coupled with a smooth ability to cut through the grease of wordy, "unpleasant" complexities and historically grounded explanations, made for the stuff of Warhol's work. The fashion illustration, the early "easel" work, the repertoire of silk-screen virtuosities, the paintings, the movies, *Interview,* the photographic activity, the books, and the resonant figure of Andy himself, were informed by a coldly smart reading of American culture. He cannily appropriated a seriality of signs, jokes, and icons that seemed right on the nose. But that's not surprising, since Warhol was so taken with the face of things.

It was this face, this parade of glaringly alluring visages, that soaked through Warhol's production, that floated to the surface of his work and showed us how images of certain well-known and sometimes smiling heads could make idleness seem so awfully busy. Inhabiting a kind of gauzy villa of narcotized smirks, they might even suggest, beyond the irony, a passion. The passion for the elegant figure. The grace of a stunning body working a gorgeous garment. Indigo-shadowed eyes glancing at a boy who's always looking the other way. We are breathing

inaccessibility. Our desire is merely to desire. We must see and be seen and the next party is always the best.

Mixing scattered serialities with the promiscuous capabilities of the silk-screen process, Warhol crammed his images with the commodities and commotions of his time, and made them belt out a national anthem which sounded suspiciously like "Money Changes Everything." The singularity of specific icons was processed through an assembly line of fluent, varietal repetitions. But although these procedures were employed with machine-like detachment, the work, nevertheless, has the feel of a cottage industry in which the tiny mismatches and eccentric registers of the silk-screen process become as resonant as de Kooning's rapturously brushy orchestrations. From the ironic presentation of the renovation of affliction (the nose job, dance instruction, and paint-by-numbers pictures) to his portraiture, Warhol's images coalesced into a facetious cataloguing of photographic and painterly gesture: a testament to inaccessibility, to the rumor of a stainless beauty, to the constancy of glamorous expenditure.

The toney veneer of these incisive parodies and icy vanities could serve as screens on which to project Warhol's raw and powerfully tedious movies. *Kiss, Blowjob, 13 Most Beautiful Women, Poor Little Rich Girl, Screentest, Face, Chelsea Girls,* and even *Empire* (with its attention to the "face" of an anthemic structure), all seem to be searching for the perfect visage. The "up close and personal" talking head, coupled with the enlargement of the film format, produced the ironically doubled myth of "Super Star": a site at which the marginalized could enthu-

siastically produce the image of their own (im)perfection: in which the generic position of "star" was doubled over and, rather than choking on its own artifice, swallowed it whole and proceeded to describe the experience to us for what seemed like an eternity. By suggesting that people could spend their lives lying in bed, talking on the phone, and cutting their bangs, these films foregrounded both the fun and charm of being wasted, and the hard work it takes to live another day. They create different readings than the gelled signifiers of the static portraiture, and proceed to tell a story about the thin line between glamour and shit. They satirize, yet embody, the star system, the impossibility of everything, and the sublimity of the mundane gesture. They are contemptuous of the spectator as masochist and invite an intelligently hasty exit. They are clean-cut examples of film as idea, combining the "creative" dispensations of so-called avant-garde filmmaking with the look of Sam Fuller's perpetual complaint that someone is staring at him.

Throughout all this work, Warhol functioned as a kind of engineer of retention: a withholder who became the door-keeper at the floodgates of someone else's expurgatory inclinations. His acuity can be construed as a kind of coolness: an ability to collapse the complexities and nuances of language and experience into the chilled silences of the frozen gesture. He elevated the reductivism of myth and mute iconography to new heights of incommunicado. Mixing the posing of stunned subjectivity with the confessional forays of raging objectification, he produced something that sometimes looked like a talent show in the asylum. Like any good voyeur, he had a knack for

defining sex as nostalgia for sex, and he understood the cool
hum of power that resides not in hot expulsions of verbiage, but
in the elegantly mute thrall of sign language.

1987

Prick Up Your Ears

At times it seems possible to divide the world into two types of people: creeps and assholes. These are not strict categories, of course, but merely ways of tracing tendencies and predilections. For example, creeps are usually wound neat and tight and seldom say what they mean or mean what they say. Always busy plotting, strategizing, and working the angles, they know there's no such thing as paranoia, because everything you suspect might be happening actually *is* happening. And they make it happen. There's no noise, no candor, just the cool hum of retentive calculation. But you always know what to expect from assholes. Because they thrive on transgression, their brashness becomes both fun and predictable. They'll never betray you because they never say anything behind your back that they haven't already said to your face. Every thought is deemed right enough to be spoken, every opinion real enough to be fact, every shit sweet enough to be bronzed.

All this brings us, naturally, to Howard Stern. Stern is vintage gaping asshole (relax Howard, it's a compliment): a state-of-the-art, world-class rendition of the genre, increasingly known for his willingness to say the wrong thing. And since those of us who tune into his morning radio show are treated to myriad descriptions of his cellulite-ridden buttocks and anal fissures, I'd like to think of his assholism in both the physical and intellectual sense. His unrelenting penchant for "truth"-telling, his dumbly extemporaneous brand of performance art,

serves as a kind of leveler: a listening experience that cuts through the crap, through the deluded pretensions of fame, through the inflated rhetoric of prominence. Jabbing at the greasy machinations of power and control, he succeeds as only a big-time control freak and power abuser can. Zigzagging between self-degradation and megalomania, political clarity and dangerous stereotyping, temper tantrums and ridiculously ingratiating self-interest, he is both painfully unsettling and crazily funny.

In fact, Stern's coupling of full-force rebuke with relaxed, conversational loitering has captured the market in New York morning radio, and it's only a matter of time before Los Angeles follows suit. And why not? He simply has no competition. For if radio in general is mired in horrendously tedious playlists, dumbly droning deejays, and tiresome oldies stations, then morning talk radio is even less than zero. There's plenty of yapping going on in the hours before noon. But across the country the genre is motored by a bunch of bland chumps trying desperately to hook the listener with the same dumb formula. Never have so many worked so hard, so pathetically, to be "outrageous." Y'know, just a bunch of really wild-and-crazy, far-out, wacky kinds of guys who, for all their toil and trouble, for all their strenuously choreographed "antics," wind up sad, dull, and worst of all, unfunny.

But Howard Stern makes it look easy. Truly enraptured by the sound of his own voice (or belches or farts), he seems intent on bringing candor to new highs in lows, on reminding us of the troubling complexities, pleasures, and horrors that only a major asshole can deliver. From a generalized fascination with

bodily functions (his oft-stated belief in the transgressive powers of the word *doody* and his advice on bathroom etiquette, "You should always flush twice. I believe in a courtesy flush") to explicit sexual descriptions, from silly pontifications on current events ("How can Jeffrey Dahmer get a fair trial unless there are more guys who want to have sex with dead men on the jury?") to incessantly jokey put-downs of both friends and enemies, he takes us back to another place and time . . . junior high school. His inability to be a good boy, his blow-by-blow descriptions of his own masturbation and flying love gunk, his constant complaining about his penis size ("I'm hung like a pimple"), all work to encourage both intense embarrassment and rollicking self-recognition in the heart, mind, and groin of his ideal listener: the boy buried not too deeply in most straight, white men; the boy who most keenly feels the exhilarating yet excruciating goose of Stern's grabby, empathetic device, who most profoundly yields to the *Yo, dude*-ness of it all.

But that's the radio Howard. The TV Howard is something less. Less given to free associating, less anarchic, less vocal, less funny. He's more literal, more part of the conventions of the medium: the predictableness of stage sets, the constant tits and ass, the cruelly voracious need to recruit anyone pathetic enough to want to make spectacles of themselves. The radio Howard is not as self-censoring about what can and cannot be said, and more apt to banter with his beloved posse of quasi masochists, his studio crew. In fact, one wonders how the show would function without sidekick and resident woman of color Robin Quivers, whose giggly commentary on Stern's every tic, whim, and kvetch serves as an anchor of sorts, bringing the real

world into Howard's world by plying him with juicy news items in the hope of detonating the virtuoso retort, of pushing the button that unleashes the raging mother of all riffs that can motor the show for as many minutes as possible. Stern, Robin, Jackie "The Jokeman" Martling, Gary "Baba Booey" Dell'Abate, Fred Norris, and Stuttering John Melendez seem to comprise a kind of geriatric homeroom that nudges bleary-eyed listeners into the day and eases the drive time.

Spitting out whatever crawls to the tip of his tongue, Stern drones on about his inability to "bang" his wife, disses the tenth-rate show-biz schticksters who are perpetually ripping him off (so true), comes on weird to women ("My wife has breast cancer. She told me to start dating"), and plays tapes of the pivotal moments that fill his universe: outrageously dumb sound bites of politicians, rock stars, and any other foolish hideosities stupid enough to speak their "minds." One vintage segment is an airing of an ancient tape of a Stern family outing to Howard's recording engineer father's studio, where Howard and his sister Ellen are quizzed on current events. Little Howard, already a wise guy but still a soprano, proceeds to drive his father crazy with his un-Einstein-like antics. Pushed to the limit, Daddy releases a torrent of frustration and contempt, bellowing "Shut up, you moron!" In fact, it is this inherited refrain, blurted out in the same tone of voice, that serves as a kind of mantra for the entire Sternian enterprise: a perpetually indicting bee in Howard's bonnet (and that hairdo is definitely a bonnet). From his jerky adolescent fantasies about women, to his callous goofing on gays and lesbians, to his deeply disturbing Fear of a Black Planet, Stern, at times, embodies the kind of

dangerously unexamined populism that is so prevalent in America today. Caught between patriotism and disenchantment, he spouts the false humilities of "common sense" and reaffirms the meanest of stereotypes. He's like an antenna for received ideas: absorbing all the dumb assumptions he's been fed (what else could explain his gullible pro-Reagan/Bush voting record, which he now regrets) and rebroadcasting them to an audience of avid dudes.

But Stern is no Morton Downey, Jr., Joe Pyne, Rush Limbaugh, or Andrew Dice Clay. Stern is funny. Really funny. And that's where things get complicated. Because funny can cut at least two ways. What makes us laugh are not just the ironic musings of an examined life but also the fascinating arrogance of stupidity. Stern's gift (or curse) is his ability to deliver an abundance of both. And it is this coupling of reasoned goofing with over-the-top fear and loathing that creates ambivalence and extends his audience into surprising areas. For while objectifying woman as the seminal receptacle of his dreams, his ideally mute jismbox, Stern remains vehemently pro-choice and has been issuing the most powerful indictments of the Reagan/Bush anti-abortion agenda ever heard in the media. Worked up to a fever pitch, he screeches that any woman who votes for Bush might as well put her vagina in an envelope and mail it to the White House, since she is literally giving the Bush Administration control over her body. (Right on, Howard.) And his run-ins with the FCC have transformed him into a mouthpiece for First Amendment rights, causing him to rage on about the stacking of the Supreme Court with pathetic right-wing mediocrities.

Stern's relationship to gays and lesbians is less ambivalent, sliding from stereotypical parody to outright disgust. From "The Out of the Closet Stern Show" (celebrity interviews) to "Lesbian Dial-a-Date" (a proven ratings booster), Stern joins the conventions of gay bashing with a kind of schmoozy familiarity. But it is in the area of racial difference where he *really* loses it, abandoning ambivalence and crashing head-on into the rocky shores of contempt. Combining a pinch of '90s-style America First xenophobia with a dollop of old-fashioned race-baiting, he brings out the worst in his listeners as Robin painfully cringes through it all. Stern chooses to remain resolutely ignorant of the power of some of his stereotypical declarations, of his "ironies" that are swallowed whole by an audience which may be even less into irony and subtlety than he is.

But, of course, Stern isn't about subtlety. He's about a kind of narcissistic pathos, a spectacular self-disgust that pulls him through the swamp of his own yucky abjection. (Translation: Howard, you hate yourself and we love you for it.) He's about being *really* funny, he's about telling like it is when it really isn't, about getting intensely worked up without thinking too hard, about cutting through the grease, about living by his wits, about being *very* smart but not too intelligent, about being savvy around small, telling moments but missing the big picture, or maybe it's the other way around. He's both a third-rate sadist and a fifth-rate masochist. He's the Anticool, the walking wounded laughing all the way to the bank. He's the wake-up call that America deserves.

1992

TV Guides

April 1989

Stupidity fascinates. It is forthright. It is never self-conscious. It never listens. It says what it means and means what it says. Giving you all it's got, telling you everything, it partakes of a kind of encyclopedic self-evacuation. I'm not using the term "stupidity" in a judgmental sense (although nothing truly escapes our cataloguing of the loved and the unloved), but rather in an observational one. And aptly so, as today's most efficient provider of our daily quotient of stupidity is that most observed of objects, television: a veritable hologram of the stupid, a kind of '90s-style blob, no longer warm and organic, but cool, electronic, and dry. Fixed by its relentless delivery of doubtless declarations, we are touched by its untouchability and untouched by what we thought were touches. Its constant confessions have the velocity of an oral high colonic of such proportions that we are drenched in its residue of chattering waste and flatulent candor.

But lately, the airways seem to be held hostage by a new brand of stupidity, or so we've been told by the media pundits: further "refinements" of the infotainment genre, antic hybrids of the conventional news magazine, the rampant group confessional, and the show biz tip-sheet. Plump with hyper human interest, they appear to blur the distinctions between what's "news" and what's not. After all, "real" news isn't stupid, it's serious, right? Ted Koppel is America's dean of delicate diplomacy, right? Tom Brokaw's got a direct line to what's *really*

happening, right? When Sam Donaldson and George Will and David Brinkley have a pow-wow, they're telling it like it is, right? Not like Geraldo and Maury and Co., who yuckily crawl through all that (yuck!) violence, death, money, power, and sex. After all, "real" news is about war, disease, oppression, secret arms deals, and abortion clinic bombings, and what could these events possibly have to do with violence, death, money, power, race, and sex?

It's too easy to cavalierly dismiss the tabloid genre as sensationalizing puff and to oppose it to the integrity of "hard" news, which tends to anoint an event as truth or fiction, creating a broad consensus amidst its viewership. This is not to valorize so-called trash TV into anything more than a kind of baroquely embodied moment of the stupid, but simply to suggest that "serious" news can be seen as merely a different shade of stupidity. After all, the difference is not always in the story, but in the telling, not in the moment, but in its representations and how these representations coalesce into an official history— not that one is more informed than another, but that the mode of presentation "legitimizes" or "illegitimizes" the story. Why are we shown one picture and not another? Why this sound bite and not that one? These decisions reveal a web of preferences that are determined by economic and social relations—filtered through the heady discourse of taste—and emerge as opinion, but are never named as such. It is this constantly surveilling arena of taste that patrols the inner and outer limits of our lives, dictating to some degree our enemies and our infatuations, our past and our futures. And as far as history is concerned, some like it dry: crisp as a cleanly starched shirt, antiseptic as a well-

scrubbed surface, devoid of prints and stains, and evacuated from bodily occupations.

Hence the great divide between "high-minded" reportage and the excesses of docudramatic tall tales. This bifurcated paradigm is well established in print journalism, but TV sports a kind of sloppy *faux*-inclusivity that mixes "all the news that's fit to print" with unfit but juicy schlock exposés and topical scream sessions. Inviting us to "find your world in ours," TV literalizes the threat of our newspaper of record, collapsing the recordings of the "real" into the hyperbolic realms of fantasy, parody, and reenactment. Every report is proof positive that a human being is nothing more than an "item" wrapped in skin. Every incident is up for grabs, fodder for alteration, exploitation, and "revenue enhancement."

Perhaps what I might be suggesting is that this capacity to fascinate, coupled with a big yen for bigger bucks, makes us dumbstruck. Embalmed in a kind of electronic amniotic fluid, we are frozen like Bambi in the glare of headlights. Whether it emanates out of the mouths of "serious" kingpins or screeching buffoons, we take stupidity seriously. It can fill hours and pass time. We can look and not see. And given our blind eyes, anything goes. If nothing else, surely the past nine years have taught us that the notion of justice has become a crass irony, benevolence a sappy joke, anyone else's struggle a relief because it isn't ours. We're gripped by a discourse of taste that spews judgments with the velocity of bullets, resolute in its rightness. It inhales pathology like oxygen and dispenses it in the guise of opinion and expertise. It makes difference the enemy. Ignoring the systemic constructions of power, it focuses on the moment

and not the process, the individual and not the scene, the figure and not the body. Current events, national struggles, and sexualities are created, renewed, or canceled like sitcoms. And perhaps that makes some sense, since stupidity does seem to render everything from war to peace, from life to death, into one big and sometimes triumphant, sometimes tragic, sometimes sexy, but seldom unwatchable situation comedy. And that's not funny.

September 1990

If there's one thing that can barely escape anyone who has ever visited a court of law, it is that the term "courtroom drama" is no mere figure of speech. Legal procedures are indeed dramas: protracted narratives, perhaps less seamlessly continuous than their novelistic, theatrical, cinematic, and video kin, but nonetheless rife with twists and turns and performances that either hit or miss. This performative aspect, this attempt to re-create moments through storying, tests the acting abilities of defendants, plaintiffs, judges, witnesses, and lawyers alike. But most often it is the attorney's ability to exhort, reveal, and withhold that determines a case's outcome—a measure of the importance of her or his communication with the audience, the jurors, helping them to reconstruct a purported reality.

But it now seems that these emotive legal forays will no longer be limited to the courtroom audience. The expansion of cable TV into areas of more tightly defined interest has now spawned Court TV, a channel devoted exclusively to courtroom coverage and analysis. Less condensed than Judge Wapner's domain and less predictable than the reenactments of *Divorce Court,* it melds the continuous flow of the C-Span schematic with the narrativity of a slo-mo Perry Mason, working to snare its viewers into that familiar gulch from which all of TV's power emanates: the familiar juncture of demi-distracted fascination and narcolepsy.

Will this enlarged viewership actually change the way the

law functions, and if so, what will be lost and gained in these alterations? Lost is another moment to the covetous proclivities of spectatorship; another moment of action and volition to a process of reduction; another moment in our transformation into quasi-alert watchers who look but do not see, who are "done to" but never do. Lost is another arena to the thrall of surveillance, where if someone isn't eyeing us, we're eyeing ourselves. And this surveillance is no longer the domain of individual voyeurs, but has been appropriated into the directives of corporate control, which, along with the incursions of computer technology, have hologrammed us: replicated us through a confluence of mirror images, numerical records, immaterial desires, and concrete pleasures. We become sort of snatched bodies, pods if you will, who have also lost another bout in the protracted battle against the stereotype, as television secures the power to represent the clichés of our nightmares as the truth.

What might be gained from all this is a new view of "ethics" and "law," of how these might be social constructs rather than sublime smidgens of divine rule that have floated down to earth. What might be gained is a more sober, less idealized reading of how our notions of civility and criminality are formed. What also might be gained is a rethinking of "objectivity," that relatively unchallenged phantasm that commandeers the domains not only of law but of the press, suggesting the zany possibility of a body without preferences, without memory, without history, not a person, not a complex subject but a radiantly value-free object, untroubled by consciousness or subjectivity. Another snatched body. Another pod.

But of course video technology has already changed the

law. Tapes of violent skirmishes, brutal beatings, and national rebellions find their way from "amateur" videocams to global broadcast. The impact of videotaped confessions and the images of allegedly intoxicated drivers emerging from their vehicles are hard to deny. These tapes pay incendiary witness to the power of representation and its ability to smash or solidify the stereotypes of race, sexuality, and threat. And even a show like *L.A. Law* can affect how Americans view the legal procedure as well as how the profession views itself. But you needn't analyze the court moves of Gracie and Michael to know that lawyers who can't project their voices, construct compelling stories, and exude at least a spurt of charisma have little chance of winning any argument. TV has clearly rearranged the idea of courtroom space from a theater in the round to a flat but constant expository screen.

There is no doubt that video technology has enlarged both the performative and spectatorial aspects of our lives and transformed us all into either actors or viewers simultaneously. It permeates the social fabric, changes the feel of our human contacts, and rearranges the choreography of family affairs, sexual forays, and gatherings of all kinds. The video camera has indeed replaced the mirror as the reflection of choice, putting us in a constant state of either watching or being watched, and transforming the emancipatory notion of "play" into the relentless realm of "instant replay."

January 1986

Perhaps the most obvious feature of any rhetoric of realism is its offering of assurance; its suggestion that "yes, this is the way things look." The illustration of the seemingly real lets us know where we stand, what side we're on, and who's winning. As long as sides are being taken and good battles evil, as long as stories are climaxed and laws enacted, we can continue to think that we're in the neighborhood of ethics, principles, and truth.

We look at television. Its delivery of conventional narrative via soap operas, sitcoms, and mini-series comforts the viewer with the re-creation of proscenium-like space and the proposal of the real. It returns our look via a cast of miniature characters who declare, tease, and sing themselves into our lives. Left without a singular, continuous script but bombarded by short quasi stories and subjects without predicates (and vice versa), we search for sustained narratives and their attendant realism. But we find only segmented smidgens that "make sense," that supply us with our need for order and control. We sit and watch the little people. We hear voices. They give us "the news."

Direct-address television (most notably the news) recognizes the audience and treats it to a sort of rampant discursiveness that depends on the amplification of the crisis, the catastrophe, the event. If the American government can allude to its role in the field of "crisis management," then perhaps it can be said that the media partakes of a kind of "crisis construc-

tion." Spewing out an event a minute, news broadcasts jump from the Mediterranean to Detroit, from famine to a puppy's plaintive cry for "Kibbles and Bits." We keep up with current events.

But what is an event? A gesture framed, a statement repeated, an image reproduced, a shot fired? What happens when details are bracketed and actions extracted from the horizontal expanse of lived time and stacked to form a reconstruction of the real? Events are literally created for the media, from miniseries, whenever hostages are taken, to the structural embroilments of diplomacy and the esthetic formalities of summit meetings and state visits. These terse docudramas are stuffed into the nightly news broadcasts, which are then generously spiked with a dollop of "natural disaster" footage. While the former remind us of the strong government leaders who are taking care of both business and us, the latter—the meteorological mishaps, the "acts of God"—give airtime to our Ultimate Leader and handily distract us from what his lieutenants down here on Spaceship Earth are really up to. So while wars are fought over bruised egos and saved faces, we are treated to major coverage of natural calamities, of that which seems beyond "man's" control and through which we all suffer together. Cameras stalk the globe sniffing out clumps of "natural" morbidity ripe for representation. Broadcast worldwide, these become symbolic of "universal suffering," elicit sympathy and some money to alleviate a fraction of the problem, and are quickly forgotten, supplanted by the next atrocity in another exotic "elsewhere."

Closer to home, the media's "concern" over one of Nature's tantrums surfaced in its coverage last fall of the much-

feared Hurricane Gloria. The foreplay heralding the arrival of this monster was almost incomparable in its relentlessness, relegating nay-sayers to the role of heretics doubting both the capacity of the Almighty *and* the predictive skills of local weather forecasters. Not that the storm didn't inflict destruction and discomfort in a number of areas, but the crescendo of coverage was clearly more of an event than the purported event itself. The spectacle of mini-cams desperately scouring the streets of Manhattan for a significant puddle to substantiate the warnings of devastation was a truly ridiculous reminder of television's investment in the construction of events. Tonight promises another new saga. Pull up a chair and catch the next installment of "Mr. Brokaw's Neighborhood," in which our hero, sans cardigan, evacuates the notion of meaning from the informational and proceeds to tell it like it is, like it never was, and like it will always be.

September 1987

The yen for disclosure has always been the core of print journalism. Supposedly concerned with getting the story, it sips the leaks, spills the beans, and tells all. It embroils its readership in the increments and rubrics of narrativity, in the pleasures and pains of the text. TV journalism's transformation of print methodology, however, makes for an uneasy meeting of pictures and words. Its compelling images tend to bury the language that surrounds them, dwarfing each utterance like a slab of beef crushing a tiny sprig of garni.

Accordingly, three decades after the Army-McCarthy "hearings," we find ourselves glued to the Irangate "seeings." Ollie North, like Ronnie Reagan, is a triumph of the rhetoric of the image, tucking all unpleasant textualities behind a glazed and hunky pose that handily evacuates the specificities of the seemingly real. So what if the regulatory role of Congress has been dissolved by the shadow of the shadowy CIA? So what if anthematic sites like "democracy" have been emptied of their procedural value, and function solely as rallying cries in the battle against the yucky evil empire? Let's stop all these questions, these facts and disclosures. No more listening, just looking. Looking at Ollie, his cartoony brow, his moist doe eyes, his mouth zigzagged into a coy but smirky candor. He of the split visage, the horizontal demarcation that traipses across his facial physiogamy like a Maginot Line dividing sorrow from laughter, humility from bravado, fact from fiction. He is our

new nothing, who'll whisper sweet nothings in our ears and then "salute smartly and charge up the hill."

If North's performance in the Iran/contra-gate hearings represents a new apotheosis in the powerful rhetoric of the image, then why all this simultaneous focusing on verbal specificity and facts, on recollection and disclosure? Because though the interested parties that comprise "television" recognize that nearly all speech and text are subsumed by the seductive centrality of the image, they still want to simulate a concern with "truth," morality, and historical order. And furthermore, they know that the seductions and pleasures of the image can be increased by the riveting staying power of narrative storying. This power is based on the promises of disclosure, of exposure, of confessing. So we watch men fill courtrooms with litanies of diverted funds, diplomatic machinations, botched business deals, and covert military choreographies.

But parallel to this runs another type of spectacle, a kind of disclosure which mixes the conventions of confessing with the transgressions of undressing. This, of course, has been the domain assigned to women, since it allows them to disclose what they most economically signify: their bodies. The broadcast of their secrets violently abolishes the sanctity of the masculine voice and its investments in the labyrinthian embellishments and veilings of euphemism and rubric. Emerging like charged doyennes of the interior, their indiscretions are limited by the parameters of their bodies: from Jessica Hahn's toppling of Jim Bakker's PTL ministry, to Fawn Hall's patriotic bra-stuffing, to Donna Rice's risqué shuffling of electoral politics, to Bess Myerson's scatological meanderings and excavated jot-

tings of self-revulsion and contempt. And what has been the historical repository of some of these "secrets"? The life jacket of female reportage, the diary—the diary that, in Jennifer Levin's case (with her accounts of sexual pleasure, which she paid for with her life), echoes in the courtroom of the law of the Father, who cannily converts her female candor into self-indictment. Because they are depicted solely through the disclosures and delineations of their bodies, women are denied access to the "abstract" and are exiled far, far away from the "serious" musing, scheming, and "being in the world" of men. Their objectification guarantees that they remain always seen but seldom heard. Discouraged from defining themselves through their production, women are supported and celebrated mainly in the realm of their reproduction. As long as this remains the case, we will continue to view a steady stream of white men in suits commandeering televised "hearings" and "seeings." Defining what is "truth" and what is not, their power remains absolute until women become audible and visible, and start telling the stories of the other half of the world.

September 1989

TV is a tool. But unlike computers and chain saws, there are no directions as to its use; no how-tos, no recipes. You never forget how to use TV because you never have to learn how. Like any other relationship, it seems you just sort of "get along" with this chatty appliance; you "do" it, it "does" you. We "do" TV by letting its juices flow. Not flesh-and-blood juices, of course, but continuously acrid signals, impulses that flow from its artificial circuitry to our own. Like humans, television is sensitive to our touch. We flick a knob on its chassis and it performs for us. We know how to push its buttons. We know how to turn it on. We are clasped in a relentless tango of remote controllings. TV "does" us by holding us within its gravitational force field while at the same time letting us be. It simulates an "open" relationship, offering us a menu of seemingly multiple choices and encouraging flirtations and fickleness. We see what we think we want to see. We make mute.

An exercise in extreme and protracted power, this relationship is a meeting of serious control freaks. TV doesn't meet our demands with reticence or struggle. It talks back in a voice so diverse yet so predictable that it turns simple ventriloquism into a miasma of unmarked whispers and ambient anonymities. But it's not really talking back, even though it addresses us face to face. And we think nothing of turning our heads or disappearing for moments or hours on end. No big deal, it keeps on talking.

Television is conversant on a million topics and broadcasts itself as an exquisite generalist, an encyclopedic skimmer that avoids specificity like Dracula dodging the Cross. It flaunts a fluency in more than a few languages and speaks in hundreds of voices, juggling gender and race like a spirit trying on bodies for size, like a manic quick-change artist on a binge. It tells us jokes and grovels for laughs. It creates scenarios that elicit compassion, disgust, and everything in between. It sells time. It sells the time of our lives, the dearness of our moments for hard, cold cash. It sells us. It plies its trade through demographics; through the scientisms of polling, surveying, and surveilling.

Like any other relationship, our bond with TV is tempered by constancy. It is here, there, and everywhere, embedded in the every day and every night of it all. And with further diversification of its menu, it has become bloated with more channels, more numbers oozing movies, weather, news, and MTV. But regardless of its growing proportions, it travels well. From Miami to Bozeman, from Bangor to L.A., we are greeted by the same characters. This insistent familiarity, this soggy uniformity has the feel of a kind of generic Americana; a traveling show going nowhere, a gig that runs in place at the speed of light. It has developed a kind of pithy shorthand, a terse haiku of American symbols and power. It gets us riled up, it stirs our allegiance without our knowing what we're feeling and why we're feeling it. And feeling is just the right word, since feel is something we do with our hands. Thought comes nowhere near this process. Thought might raise messy questions. We might have to think about histories, about subtleties, about agendas, about accountability. We might have to think about

what we're being shown and told and who's doing the showing and telling. We might have to think about power and how it's granted or withheld and who's doing the granting and withholding.

But, of course, we don't have to think about anything once television lulls us to sleep and begins its dictations. Like a mad scientist of global proportions, it elects presidents, conducts diplomacy, and creates consensus: a consensus of demi-alert nappers caught halfway between the vigilance of consciousness and the fascinated numbness of stupor.

September 1986

Certain songs have a kind of hook that coaxes us into a hazily pleasurable loop-like riff between nostalgia and futurology. Certain magazines have a kind of hook that couples a seemingly endless variety of sameness with a trashy veneer of unbelievability. From *The National Enquirer* to its upscale relations *People* and *Us,* these publications emit a relentlessly ridiculous yet compelling rendition of information and its relationship to "celebrity." This magazine format has also invaded television, emerging in the form of news-like presentations and life-style shows. The most persistently visible examples of the genre, and not coincidentally those with the biggest hooks and the most juice, are *Entertainment Tonight* and *Lifestyles of the Rich and Famous,* which light up American homes with their baroquely unbridled reports from the end of the rainbow.

While *Entertainment Tonight* focuses on the processes of production and the business of show business, *Lifestyles of the Rich and Famous* sloppily paddles through the extremities of reward, through the acquisitions that accumulate after the deals are made, the public delivers its verdict, or the family delivers its inheritance. Bellowing at the top of his lungs, Robin Leach dominates the proceedings with his sideshow bark and his "If this is Tuesday it must be Belgium" travel agenda. Rushing from Wayne Newton's lavish spread to gun merchant Adnan Khashoggi's birthday party to Valerie Perrine's jaunt through the South of France, Leach lets the audience in on the stuff they

will never forget: that money can buy you love, and that the best things in life are never free.

Like *Dynasty* and *Dallas, Lifestyles* works hard to delineate the difference between having and having not, but television's penchant for evacuating meanings and roughing up the mechanics of transference and identification plays havoc with the viewer's actual positioning. We can observe the proceedings with distanced amusement, giggling at its excesses and possibly resisting its almost undeclinable invitations. Or we can project madly into the melee, perhaps believing that if we use the right bubble bath or drive the right car, then poof!, we're Alexis or Adnan. Through these tenacious transmissions (which reflect the Reagan administration's fertile fantasy life), voyeurism's rewards are presented not as ditzy fabulations but as the real stuff of our lives. Convincing us that seeing is not only believing but becoming, *Lifestyles'* flamboyant flaunting of baubles and bucks seems to efface rather than enhance the difference between rich and not. So, after a hard day's work, couch potatoes are snappily transformed into duchesses and dreamboats as the hard reality of our everyday labor (or lack of it) is handily dematerialized. Everybody's an executive adrift in their own inner space, suctioned up by the powerful seductions of managerial power and perks.

Entertainment Tonight breaks down this seduction a bit by focusing on the work that paves the way for reward and on the actual mechanics of profit and loss. Perched on contempo chairs that float in a space that resembles a black hole furnished by Conran's, the duo in charge spout a tidy continuum of juiced-up reportage. From a relatively detailed accounting of the gov-

ernment's attempt to curtail the distribution of critical documentary films to the latest industry gossip on a hot new canine star's next career move, the presentation zigzags wildly between earnest liberal exhortation and fan-mag gush. But framing this narrative lowdown is a constant numerical barrage of box office statistics, celebs' birthdays, and audience demographics, which, although informational in its foregrounding of market valuations and career longevity, soon becomes, through its perky yet trance-like recitation, almost pataphysical if not downright otherworldly. If *Lifestyles* cultivates the rich terrain of the spectators' inner space, then perhaps *Entertainment Tonight* is claiming the turf of numerical capital as its outer space. Could it be just a coincidence that the hosts in charge affectionately allude to their cozy little mother ship as "ET"?

Unlike *Lifestyles'* frenzied myopia, *"ET"*'s long view goes a short way to expose the underpinnings of America's love affair with power and celebrity. But these meager efforts are hardly enough to break the spell. Together with *Lifestyles'* and Leach's newest entry, *Fame, Fortune and Romance, Entertainment Tonight* reminds its viewers to sit back, relax, and live the fantasy—to blast off into an outer and inner space where living well is the best revenge.

May 1986

Girl/boy crime-busting duos have sleuthed their way through decades of black-and-white mystery films and color caper movies and are now a staple of prime-time TV programming. From *Mr. and Mrs. North* to *Moonlighting,* the genre has functioned not only as a pleasurable mix of sneaking and sexing, but also as a succinct barometer of the dispensations of the duo: of what is shared and who is slighted and how all this defines the division of labor. Early examples of the genre required the couple to be hitched, exceptionally solvent, and unusually susceptible to the scenes of crimes. In this way, *Mr. and Mrs. North* is clearly the antecedent of television's *Hart to Hart,* in which Jennifer and Jonathan Hart (Stephanie Powers and Robert Wagner) mate matrimony with material witnesses and seem to attract ulterior motives like crawlies to a roach motel. Swathed in glamorous expenditure and showering one another with "dahlings," they crime-bust their way from continent to continent via private jet, just one of the perks supplied by Hart Industries, a corporation of whose manufacture and services we know nothing. Consisting of plush offices and far-flung subsidiaries, the company is evacuated from the site of actual labor and appears as a model of today's nearly intangible service industries. We never see Jonathan "on the job," and although Jennifer floats through her various hobbies with grace and virtuosity, she (along with Max the butler and Freeway the dog) is seen as just another

corporate perk, a reward that Jonathan treats with respect and humor.

The generically structured corporation whose non-specificity seems suspect also surfaces in *Scarecrow and Mrs. King*. Our suspicions are confirmed when we discover that Lee Stetson (Bruce Boxleitner) and Amanda King (Kate Jackson), who are ostensibly employed by Federal Films, are actually Federal agents pitted against the various evil empires that threaten the American government. If all this weren't enough of a throwback to the '50s, Amanda is ensconced in a little white-picket-fenced number in the D.C. suburbs which she inhabits with her mom and two kids, who have no idea that she lives a vicarious double life. And although she handles her assignments with decisiveness, she is generally sketched as an able but befuddled puritan, a ditzy housewife with weird hours. And, of course, she and Lee barely brush up against one another.

If *Hart to Hart* and *Scarecrow and Mrs. King* suggest that Jennifer and Amanda's deductive prowess exists only through the largess of corporate and government sanction, the more recent examples of the genre focus on independent women who make it their business to own their own business. But regardless of their investigative acumen, they still rely upon and enjoy the company of men as both partners and "fronts." In *Remington Steele,* Laura Holt (Stephanie Zimbalist) uses the name and body of Steele (Pierce Brosnan) to establish the credibility of her sleuthing venture (which once again is housed in the omnipresent plush offices). Though she engineers much of the goings-on, she frequently defers to Steele in order to per-

petuate her fabulation of non-control. The series also suffers the affliction that strikes all current examples of the genre: the postponement of the couple's sexual pleasure in order to fan the viewer's desire. This season Laura and Steele actually do embrace and kiss, but their relationship remains one of conversational seductions and competitive prowess. Pitting Steele's smooth demeanor and lightning command of movie trivia against Laura's entrepreneurship and enlightened bachelorette-hood, the series renders a "battle of the sexes" in which the warriors seem to be driven to distraction by their attempts to pelt each other to death with candy kisses.

But this battle of the bon mots reaches truly pleasurable new heights in *Moonlighting,* in which Maddie Hayes (Cybil Shepherd) and David Addison (Bruce Willis) enter hand-to-hand combat in the war of the words. As in *Remington Steele,* the woman runs the shop (once again the proverbial plush offices) and takes on David as a partner in the Blue Moon detective agency, which is overstaffed with a flock of loitering misfits. Although these peripheral characterizations are witty and well drawn, the real pleasures of the show are the intricate idiosyncracies of its scenario and the wonderfully smart rapid-fire repartee that runs relays between David and Maddie's mouths. Willis' David is that charming kind of fast-talking gorilla to whom many women spend their entire lives trying to build up an immunity, while Shepherd's Maddie is effective in a wonderfully played and constantly perturbed but ladylike sort of way. But although capable of silencing David's rants with haughty aplomb, she all too frequently is scripted to appear at a

loss for words, responding instead with adorable grunt-like musings and grimaces which dishevel her lovely visage *just* enough. Aside from this *very* unfortunate convention, *Moonlighting* is chock-full of cute mini-transgressions: smallish formal innovations which define its difference from the usual hack products that dominate prime-time TV. A recent episode sported a pre-title sequence in which Maddie and David addressed the audience and acknowledged that they had received a great deal of mail questioning when they were going to get it on or at least kiss. David wanted to do it right then and there but Maddie insisted that it wasn't in that week's script and she couldn't possibly indulge in such unscripted pleasures. This portrayal of a female character as unable to proceed without the sanctions of the usually male-manufactured text was excruciatingly on the mark but was depicted in a painfully uncritical manner. Nevertheless, the extension out of the narrative was a nice formal device and served to foreground the abstinence that stalks the genre. Some episodes of *Moonlighting* hopscotch from color to black-and-white and back, while others raise the meandering delights of the detective saga to new levels of lovable silliness.

The changes that the crime-busting mode has undergone over the past forty years show us how visual and literary forms develop in little fits and stops and starts. These alterations are both the impetuses for and the results of the times in which they were produced. If Maddie and David are the current "state of the art," then hopefully we can look forward to a future where the pleasures of verbal and sexual reciprocity flood prime-time

television; where the role of the sexy, devil-may-care, fast-talking but affectionate asshole can be filled by either sex; and where it is easily understood that two equally gregarious assholes are not only better than one but can solve the crime in half the time.

Summer 1988

Crank up the old democracy machine, it's election time again. Oil its rusty spokes, resuscitate its finicky engine, and push it into the center ring, into the circus of symbolic antiquities that serve as a front for the motors of power running the show. And what a show it is! Everything is designed and constructed around a calculated frenzy of posing, polling, and Q&A. It was the notion of the vote that laid the groundwork for the development of the mass media, and accordingly they reach their crescendo of fictive consensus through the elaborate entertainments of electoral politics. Opinion is not produced but reproduced, and candidates don't have visions, they are visions— told and shown via our favorite light source, the aptly named television.

Beaming out lures of phantom meaning, TV reproduces and decorates a singular model whose methodology is the hologram of immediacy. You are there. This is happening now. Steadicams stalk the campaign trail, creating a rampant seriality of docudramatic proportions: victory and defeat, pride and humiliation are all tucked into a neat package of "instantaneous" reportage. The perpetual subtext that meanders through all of this is the constancy of polls and statistics, an inescapable dose of numerical narrativity that constructs and collapses "public opinion" with a kind of hydraulic ease. Television allows these numbers the luxury of constant display, in a sort of figurative exhibitionism that differs little from the medium's production

of a bevy of other well-financed figures, the "candidates," who could be the answers to the following questions: what happens when activity is freeze-framed, excerpted from a body of events and transformed into a static figure? What happens when the innards of functionality are siphoned from the body, in a sort of sacrificial subtraction? What is this figure that eschews the purportedly real with a backhanded compliment and blasts into the symbolic with the hot fury of an ice cube? What is this word "candidate," with its relation to the "candid," the "patently sincere"? How does this figurine fill in the stereotypes of concern, candor, and sincerity?

But what am I getting at? Why am I loitering so questioningly and questionably between doubt and belief? Perhaps because the terrain is so treacherous, so fraught with unspeakable debasements and tumbles from grace. Perhaps it's just a bit much, this notion that American democracy, our national anthem, could be vulnerable to depletion, reduced to a "going through the motions," a choreography of gestures, a kind of robocracy; maybe even in this remaindered state it exudes an auratic kindness, a memory of the generosity originally intended in it. But it should be remembered that what I'm trying to talk about is not "democracy" but how it is constructed through representation; through the electronic transmission of pictures and words; through television. And anyway, how does one speak of democracy without collapsing into a treacly puddle? How does one describe this inclusive ceremony of benevolence without folding into doltish self-parody? For what and whose purposes are we allowed to bask in the warmth of civic affection promised by the democratic model? How aware are we of

attempts to appropriate this process of plentitude, to convert it into a kind of figurative deficit, a battle cry for the stingy, the laughless, the gangster? Democracy. Like all words, it's up for grabs. Television makes presidents. Who are you voting for? Who's on *Nightline*?

January 1987

A giant wrist invades the TV screen, larger than life and sporting pores the size of M&Ms. Loosely embracing its circumference is a light gold bracelet, which, magnified by the camera, takes on the dimensions of a bicycle chain. The wrist rotates slightly, causing the bracelet's facets to dazzle the eye while a voice brassily hawks the virtues of this yellowish metallic object, extolling its gorgeousness and bargain-basement price tag. In quick succession, another item appears, an 18-karat gold chain propped up on a piece of velvet and nudged by an insinuating gaily colored wand. Sometimes the displayed object is seductively caressed by an errant finger, but whatever the technique, the aim is the same: to animate and sexualize the merchandise, to heighten the gleam of its illusory promise.

This promise is being delivered to us via *The Home Shopping Club,* one of the telephone-order "consumer services" now broadcast all day and all night to well over 40 million American homes via UHF and cable-TV channels, and just how illusory it is surfaces during the regularly aired telephone conversations with some prospective purchasers of the goods. Dorrie, Larry, Lisa, and a chorus of other breathlessly vociferous hosts bury the nervously reticent callers in a melange of superfluous, highly veneered niceties, a kind of have-a-nice-day prose rife with hard-sell vagaries and false concern. These calls take the form of articulately wrought American tragedies, short and poignant indicators of lives motored by the rapid movement of capital,

by massive constructs of control, and by a wizened, cruel memory of what human contact and exchange feel like.

Like the cable-TV services such as Home Box Office which provide movies for TV consumption, the evangelical machinations of *The Home Shopping Club* foreground the home as the nexus of receivership, relocating visual and commercial reception from the movie theater, city street, or shopping mall to the seemingly private shelter of the living room. Accordingly, *The Home Shopping Club*'s logo is an outline of a house with the club's monogram nestled cozily within it. In many American cities and suburbs, pedestrian loitering, browsing, and cruising is increasingly limited to specific self-contained areas. With television as the vector of control and command, expeditions "outside" become sporadic and predetermined. The nooks and crannies of social relations, from mercantile wranglings to romantic tussles, are ironed out into a smooth, seamless continuum of demi-associated moments. In addition, information has been transformed from a raw material into a highly directive demographic tool. The active collapses into the passive, and the increasingly archaic idea of volition is left loitering around one of the few enterprises still available to it: shopping.

Whether under the auspices of *The Home Shopping Club*, the shopping mall, the stock exchange, or the auction house, the motor of continuance is the pitch of "choice." Each economic group stalks its allowances, perusing zirconium pendants, contemporary art, stock shares, or cardigans. But these are variations on a single theme: the shopping mentality is the seductive terrain in which the acts of looking and using are dissolved by the lure of selection. Sit back, stand tall, and take your choice.

January 1988

Whether the news is good or bad, whether it's sunny or sleeting outside, regardless of the conditions of their domestic milieu, morning-TV viewers remain privy to a tableau of faux-lived-in midbrow cheer: burnished orange rooms abloom with botany and padded with pillows. These implacable interiors are invariably graced with quaintly paned picture windows which appear to look out into the world. But if we look carefully we might notice that these are not rooms with a view but rather trompe-l'oeil vistas, rendered in the same stunned casualness of the interiors. The stunned casualness of the viewers might be interrupted when we realize that we're boxed in, that the windows are no way out, that we are blinded by the blinds and there's no escape through the fake landscapes and cityscapes painted on them. Nothing can rip asunder the "alwaysness" of this sheltered interior—no war, no natural disaster, no political conflict can soil or dishevel the sanctity of this homey order. What a perfect place to "do" the news.

And indeed, that is just what is "done" here, as the networks usher in the day with a dollop of global goings-on. But rather than taking any sort of precedence, the news is just a smidgen buried amidst volumes of magazine-style factoids, ranging from hot-shot personality portraits to consumer tips to medical advice to locker-room chatter to endless expanses of weather prediction. Locking horns from 7 to 9 A.M., the networks stage a kind of "Home is where the heart is" havoc, a

minute-by-minute pitting of *Good Morning America*'s breakfast-nook vigilance against Bryant and Jane's perkily mannered niceties on *The Today Show* and the late and unlamented *Morning Program*'s inept mining of homespun coziness. The airwaves are choked with pinches of human interest (David Hartman's narcoleptic report on the plight of the Native American, for example), and with interviews with the show-biz sex object of the moment (Harry Hamlin's ample lips were interviewed by both CBS and ABC within the same half-hour segment); a dog-trainer runs her favorite pooch through its paces, and Daniel Ortega drops in to state his case (allowing the networks once again to supply their highly questionable diplomatic channels, which loom all the larger because they replace—not without a lot of help from the government—the notion of representative government with the governance of representation), all this prefacing a flower arranger who tells us how to groom a bloom.

Every half hour this "life" is interrupted by five minutes of the "world," a capsule commentary concerning the murky otherness that surrounds and threatens the supposed autonomy of these burnished orange dens, these demi-high-tech kitchens, these domestic dioramas. The switch to this "news" segment varies stylistically from network to network. On *The Today Show* Bryant Gumbel and Jane Pauley cut to a newsman, John Palmer, who is propped up in front of a blue-and-white striated map of the world. On ABC and CBS something more interesting happens: when the household hosts switch to the news anchor they simply swivel around in their seats and glance over to the smallish TV perched on the kitchen counter or the coffee table—you know, just like we folks at home do.

Constructed as they are, these programs purport to repre-sent "life" via decor and life-style, all the while introducing us to the people who "matter." Despite the difficulty of procuring shelter in America, despite decades of institutionalized racism, despite the ravenous specter of AIDS, despite a burgeoning homeless population, even perhaps *because* of all these factors, the networks' presentation of domestic comfort functions as a powerful sedative. From "A man's home is his castle" to the corporate construction of each viewer's "Home Box Office," the sanctity of interior encapsulation remains sturdily intact, reinforced by the desire to separate the domestic refuges of "life" from the alien rampages of the "world." So what we get is quite literally a "happy medium": you give us five minutes, we give you the world.

November 1989

Who is this guy? What is this guy? Glistening hair floats over a militantly loosened collar stuffed into a shiny, expensive, ill-fitting suit. The camera closes in on a familiar face. This guy is taking advantage of just about the only airtime he's had this year. Aside from brief sightings on *Wiseguy,* the Labor Day Telethon is *it* for Jerry Lewis. Ordinarily, to get this much attention he'd have to schlep to Paris. You see, in France Jerry Lewis is considered a genius. This last sentence is the funniest thing that ever happened anywhere near Jerry Lewis, which is disappointing since he's supposed to be a comedian. Who thinks Jerry Lewis is funny (besides the French)? True, funniness, like most other attributes, is constructed in part through taste. True, one person's sirloin is another person's kitty stew. But really, who thinks Jerry Lewis is funny? Perhaps he's about far more serious stuff. Perhaps Jerry Lewis is about a kind of abjection; a glistening knot of anger and petulance marinated in a soup of vindictive disingenuousness. (Write him for the recipe.)

But on second thought, comedy is always dead serious. Every parodic moment, every smidgen of irony, every giggle and smile is detonated by the feel of our lives; by moments that can be so weighted by sadness that they might only be experienced through farce. This farcical view can be a mediating force that acts upon gestures and emotions, coating them with the sheen of commentary, with the gloss of parody. This para-ode, this song alongside of, can break down the exaltedness of sacred

cows and expose the delusion that lurks beneath every arrogant moment. So maybe Jerry Lewis, in his extreme expository projection of what it's like to live a lie, really is a genius. (Just kidding.)

The pathos of comedy can shed light, allowing us to view the image of our own imperfection with generosity rather than fear and loathing. It can deliver a dose of vigilant self-examination that might temper us with a kind of joyous sobriety. But in its un-self-conscious form it might offer itself up as an object of derision, ripe for the pickings of camp and the manias of ridicule. The Labor Day Telethon clearly belongs to the latter genre, vomiting up 22 hours of non-stop vanity and stupendously riveting self-aggrandizement. Jerry and his side-kicks, Sammy Davis, Jr., and Tony Orlando, form a kind of shimmering trinity of outrageous schticksterism, oozing with every show-biz cliché, every bad dream of what it might mean to be an "entertainer." But while Sammy has grown a bit wiser with time and Tony more tolerable simply because he's *never* around, Jerry just keeps on keeping on. From the show's lunatic beginning (an insane rendition of the Rockettes gigging in Tiananmen Square) to Jerry's trademark sign-off (his faux-human go at "You'll Never Walk Alone"), the entire production is marked by the distortions and distractions of the old schlockmeister himself.

From shedding his first telethonic tear at precisely 9:33 EST, to holding little Ashley, the Muscular Dystrophy Association National Poster Girl, like a hand puppet, to swabbing the sweat off his face as he stalks the stage for the next human who'll obsequiously grovel at his feet and give him money, to sliding

millions of dollars worth of corporate checks into his pocket as his face locks into a failed imitation of humble thankfulness, to wheeling down a supermarket "Aisle of Smiles" with one of his "kids" stuffed into a shopping cart, Jerry is out to prove just how great his greatness can be. It's a campaign of sorts, emblazoned with a truly spectacular spew of self-testimonials: "I don't need cue cards. I could just speak my guts out and it sounds terrific." "I remember things, I'm good with numbers." "Winston Churchill said 'I'm a simple man, I like the best of everything.' I'm like that too." Dozens of these blatant self-tributes litter the telethon like tiny pellets of shit waiting to be bronzed. It appears that Jerry really is campaigning for something he believes he clearly deserves, like a Nobel Prize perhaps, or a cabinet post.

But watching this megalomaniacal lunge for the brass ring is obviously made a bit more complex when joined to the charitable function of the telethon. It cannot be denied that this frantic vanity production has raised hundreds of millions of dollars over the past 24 years to benefit the Muscular Dystrophy Association, and that's no joke. In a country with the most minimal government support for health care, where millions are uninsured, where getting sick can mean total economic ruin and premature death, it is estimable that a private effort can raise so much money for care and research. One's taste in comedians should not obscure the lives that are touched and the issues raised by an event like this. But something more complicated is afoot here. Despite raising huge sums, despite doing a great deal of good, these attributes are undoubtedly secondary and tertiary concerns on the Lewisian agenda. And that's what makes the

telethon so compelling a travesty and so riveting a pastime. Because what's primary to Jerry is Jerry. Barking out his abilities, flaunting his peccadilloes, and taking charge with a kind of incessantly bullying mean-spiritedness, he is nothing less than a shark on a spree. And when you really think about it, there's an elegant sense of symmetry to it all: a neat tale of salutary penance. Jerry Lewis' career was motored by his blatant characterization of physical affliction. Whether he was a Melvin or a Marvin, he was the stereotypical portrait of ingratiatingly kind disability, which dared not speak its name. Arms wildly gesturing, legs akimbo, constantly yelling "waaaaaaaaaaah!," he was the apotheosis of what Jerry could never be: naive and good. So not only is Lewis a singer, a dancer, a comedian, an auteur, an orchestral conductor, a philanthropist, a writer, and a good memorizer. Perhaps, most importantly, he is his own best Poster Boy.

March 1986

Deciphering who's really who in TV's world of substitutional histories and circuitous ventriloquisms is a game that hardly anyone wants to play. Things are accepted at face value, at the surface of the screen, because the audience thinks this scrim of fascination is all the medium has to give. And the scrim is usually more than enough. Offering itself up as a rest stop for wandering eyes, the tube offers a parade of personalities masquerading either as other personalities or merely as themselves. Neither real nor illusory, they appear and disappear at the flick of a switch, controlled by some remote idea of what is fit for the moment or what might be better.

In a recent episode of *Miami Vice* directed by its star Don Johnson, a retired army man is exposed as a major drug-dealer busy distributing product left over from his days in Vietnam: killer heroin contaminated by wood alcohol. It seems the captain was shipping the drug back from Nam in the body-bags of dead combatants, and the alcohol had been used to preserve the corpses. And who portrays this "pig," this necro-monstro whose office walls are lined with photos of Richard Nixon and Henry Kissinger? Why, none other than G. Gordon Liddy, of *Watergate,* the mini-series that thrilled and entertained us over a decade ago. Considering *Vice*'s proclivities toward embroidering the seamier (as in Versace) side of life, the mind boggles at the casting possibilities to come: Robert Vesco as a smuggler hot

into stuffing toot up the innards of lava lamps to be sold on the tonier boulevards of New York and L.A., and Chuck Colson as a dealer turned born-again Christian hawking courses on how to get rich quick by buying real estate for no money down.

This human exchangeability was the subject of a recent installment of *Amazing Stories,* Steven Spielberg's ongoing joke on and homage to the cute joys and even cuter tribulations of life in the good ole US of A. "Remote Control Man," directed by Bob Clarke, tells the story of a poor schnook who is victimized by the entire kit and caboodle of his traumatic domestic life and turns for solace to (surprise!) his TV. His nagging wife gets pissed off, so she sells the TV for a new pair of pumps and all hell breaks loose. In the usual whiz-bang sci-fi manner, the husband winds up with a spectacular replacement, a video appliance that makes the term "state of the art" seem archaic. Propped up in his chair, remote-control device grasped tightly in his chubby little hands, the schnook is able to zap his family into scores of character mutations and to fill his house with a veritable army of TV celebs. Bounding out of the screen at the speed of light, they nudge, cajole, and crusade their way into his domain, making his delirious family squabbles seem like a slow day at the library. Barbara Billingsly, recreating the role of June Cleaver, makes his breakfast, and his son is transformed into Gary Coleman. Richard Simmons, Lyle Alzado, the Hulk, and Ed McMahon are but a smidgen of the onslaught that converts what he thought would be heaven into a semi-living hell. In response to the schnook's frantic questions as to why this star-studded gang is occupying his living room, the grinning

celebs reply, "What are you asking me for? I'm just a character on TV! I'm not real." "Don't be such a wimp." "Turn on to people, not to the boob tube. Turn on to your wife and kids."

So what are Spielberg and Co. trying to tell us? That the characterological simulations of television must be dislodged? That the rhetoric of the real must be reestablished amidst the morass of electronic duplications? That we should abandon the dictates of our favorite light source and return to the clumps of figures that constitute our notion of the family? Of course this is being suggested, but with the full understanding that almost nothing short of nothing can treat the heavy dose of fascination that grips so many of us. And so, the folks at Amblin Entertainment figure, why not go through the motions and make like you're going for the apple pie?

The ventriloquistic capabilities of television reach their literalized apex in *Puttin' on the Hits,* a show in which contestants are judged on their lip-syncing prowess, their looks, and their originality. The latter category is a particularly poignant one, since most of the contenders appear as carbon copies of their favorite rock star, not only replicating the attire and gestures but also miming to the voices of their idols. Out of their open but mute mouths spring the vocal virtuosities of Prince, Sade, Bruce, and dozens of other current and nostalgic divinities. Bounding across the stage, the contestants act out in front of millions of viewers what was once relegated to the mirrors of teenagers' bedrooms, private arenas where air guitars and sultry poses reigned supreme. *Puttin' on the Hits* stages the charged bonding of uncritical appropriation with exhibitionism,

and grants its practitioners the right to make spectacles of themselves while making believe they're someone else.

This ventriloquism, coupled with narrative rearrangement, recently played havoc with scads of pirated videotapes of the movie *Rambo* that were smuggled into the Middle East and subtitled in French and Arabic. But along with the translation came the erasure of all references to Vietnam and the Soviet Union. The whole story was transformed to the Philippines circa 1963, where Rambo is busy rescuing POWs held by the Japanese. Sylvester Stallone's daftly rabid red, white, and blue-ism remains visually intact, but the muscle-bound hulk's rants are now accompanied by a contradictory text which propels his story to another time and another place.

This cavalier mixing and matching of pictures, words, characters, and personages foregrounds video's chameleonic flexibility. Able to be adapted to the needs not only of its authors and distributors, but ultimately, through rapidly spreading technology, of its domestic spectators, its lure is not only the promised pleasures of fascination but also those of alteration, of "creativity." Planted in our own cozy "home box offices," we not only receive the pre-packaged masquerades and lip-syncs of network TV but can also partake of our own brand of substitution, time-shifting, editing, and dubbing. This puttering and hobbyism can be seen as an alleviation of the viewers' passivity, a way of allowing us some control over the images and words of corporate culture. But these are simply rearrangements of prescribed images, or, when the footage is one's own, simply private, undistributed gestures. The power of the corporate net-

work is its ability to multiply and project its desiring voice into the larynx of its viewers, and, with a few exceptions, to marginalize and make absent what it finds undesirable and unprofitable. Whether this business-as-usual can be interrupted by the supposed freedom of visual and vocal choices granted to us by the new video and cable technologies remains to be seen. And if we, the dummies, really do start to talk back, will we merely end up selling Charmin to each other?

May 1987

Looking slightly confused, Mike Seaver is leaning against a locker in the corridor of his high school. Long lashes frame his hazel eyes, which are tinged with incredulousness, while his chubby well-formed lips are parted just a smidgen. This look belongs to Kirk Cameron, who portrays Mike on ABC's *Growing Pains*. This look has launched a thousand ships and sailed *Growing Pains* into the top ten of the most-watched TV shows. In addition, Cameron grins from the covers of gangs of fave-rave monthlies: on *Teen Beat* he dons a yellow T-shirt and a dazzling white jacket, his arms waving languorously; on *Teen Machine* he smiles a wet, toothy greeting; on *Super Teen* his broad mouth turns slightly up at the ends, tendrils of curly hair fringing the nape of his neck as he rakishly waves "Hi"; and on *Tutti Frutti* he is a casual vision in loose-fitting silver cotton. But there's more. Poster ads hawk Kirk looking "so absolutely 3 dimensional . . . it's like he's really there." And inside the fan-zines we are treated to scads of precious "pinups," "huggable centerfolds," and "exclusive interviews." We go "behind the scenes with Kirk" and are told that he is "waiting for a girl just like you," "someone who will listen to his hopes and dreams" and will win "the Kirker's" heart. Of course, all this crush-machine hullabaloo is not limited to Cameron. Other pages are splashed with pics and tips on how to win dream dates with a whole cast of favorite TV "boyfriends," each a basic carbon copy with minor adjustments in hair color or haircut. The

commodity spinoffs are there to fan the flames of young view-ers, to whoosh up their desire, tube-gluing them and boosting ratings. Accompanying this parade of sapling hunks is a back-drop of young female actors who are handed a lighter symbolic role.

Obviously, dreamboat worship is not new to TV serials, but the latest crop seems to constitute a shift, a difference, from the Ricky, David, Wally, and Beaver family phyla of yore. The current popularity of *Family Ties, Growing Pains,* and *Valerie* might suggest a renaissance in "family programming," echoing the current conservative sloganeering that foregrounds the clichés of home, hearth, family values, freckles, and apple pie. However, this does not seem to be the case. These shows do not repeat the conventional depictions of the family as the site of traditional gender and labor divisions. Rather, the family becomes a kind of makeshift consortium of laughs, labor, sad-ness, and shelter. And in yet other shows outside the male pube genre the family unit remains a shadow, frequently emerging in rearranged, surrogate versions, as in *The Facts of Life, Perfect Strangers, Who's the Boss?,* and *Golden Girls.*

As the video medium ages, its once paradigmatic charac-ters gel into stereotypical characterizations. And since stereotype exists where the body is absent, the repetitions work to deplete actual relations to individual characters and actors, transforming bodies into interchangeable figures, fugitive shapings able to accommodate quick dematerialization and generic substitu-tion—sort of an endless supply of refills. This exchangeability of desirous male objects reaches giddy heights in (the now passé pop group) Menudo's constant replenishing of its stock, expel-

ling members at the first flush of manhood. Similarly, TV sit-coms have sped up their revolving doors for young actors poised on the cusp of their sexual bloom. But because the refill represents a continuation of sameness rather than transformation, all characterization seems imperiled by a weighty stasis: by an insistent stoppage of the aging process.

The disavowal of aging and its representations conflates with the youthful demographic of a plummeting audience age which clusters around the teething set, producing an absenting, a disappearing, of the mature or dare we say pleasuring adult. Of course the promise of perpetual youth shines its light on every age group, with the help of blinding barrages of represented young beauty, ecstatically painful regimens of bodybuilding, frenzied aerobic dances to the gods of physical perfection, and tons of creams, balms, and assorted miracles. But these TV teen dreams represent dread at age 16. If Jack Benny clung to 39, today's growing pains symbolize the treacherous divide between 16 and 21, afflicting a generation whose conception of the future is better left unsaid and unshown. These kids are frozen into a population of stunned statuary, cryogenically sealed in an image that evades the possibility of passing time. They are nameless types who speak little, walk less, and fly a lot, a Peter Pan army for viewers who aren't young at heart.

November 1985

A well-oiled bicep fills the screen and flexes to the strains of the already ancient "Purple Rain." It's sort of an orange color and, in this extreme close-up viewing, totally unrecognizable as a swatch of human anatomy. It mobs the viewing aperture and looks like a cross between a slab of fatty bacon and kryptonite approaching its melting point. It is then quickly replaced by a talking roll of toilet tissue which pleads with members of a family to "touch" it. The rotund glob of needy, animated paper gives way to an anchorman, a somber talking head who reports a catastrophic plane crash. We look at images of emergency medical teams packaging the dead in yellow body bags. The runway is littered with blood and spare body parts. This segment is immediately followed by a shot of a kitten in sunglasses propped under a beach umbrella.

As this clashing litany suggests, television is the most relentless purveyor of the messages that constitute and perpetuate our severely fragmented public consciousness. It slices our attention span into increments too infinitesimal to get up and measure. Spending a large part of our lives planted in front of a piece of talking furniture, we are held hostage by the pleasure of the cutting and the repetition, by a kind of intermittent fascination which is facilitated by the relief we feel in numbness, and has the feel of the erratically riveted wonderment experienced by infants. That television's parade of segments follow one another but do not "go together" does not seem strange or

problematic to its viewers. Seen cinematically, these disjunctions might appear as affronts to narrative, or some kind of "kooky" avant-garde collage. But on TV they are just right, business as usual.

Television tells us not of a vision but of visions. It evades singularity and loiters amidst the serial, the continual, the flow. Its interest in storytelling is peripheral yet promiscuous. For although a large portion of broadcast time is given over to Hollywood-style filmic drama and the familiar closure of story-telling, television, perching in our living rooms like a babbling, over-controlling guest, is deeply embroiled in the authoritative declarations and confessionals of "direct address." The cinema frames and brackets particular incidents and in doing so reveals its connections to painting and photography, while television seems to emerge via the coupling of new picture and computer technology with the chattering of radio. As film's anecdotal accountings necessarily speak of the past, television's direct address inhabits the present. The "non-fiction" genres (news, sports, talk shows) that use direct address also appropriate the stuff of events almost instantaneously and play them back with the relentlessness of an avenging mirror. And because all this combined with ads, sitcoms, soaps, game shows, and docudramas looks like what we've come to think of as life, its simulation grants it perpetual license. Blurring the distinction between the thought and the act, between imagination and experience, TV's constant broadcast alleviates the truth of its special sanctity and sprinkles it on everything that moves.

Direct address dominates and lets the viewers think they know who's doing the talking and to whom. We know when

Dan Rather is going to break the bad news and we're not surprised when we're contradicted by a talking tub of margarine or seduced by a roll of toilet paper. We know TV meant what it said when it announced, "You Are There." We know that we have received orders not to move and that we're learning to walk in place at the speed of light.

March 1988

When there's not much else to say, people talk about the weather. And the way the network affiliates litter their news broadcasts with meteorological bombast, you'd think little else was happening in the world aside from a bit of low pressure blowing in from Canada. Just as the news is reported as a series of gestures framed and inflated into "events," so each swirl of climatic activity, each swell of sunshine or rain, is pumped up into something really big—big enough, that is, to spew dozens of adjectives and sell lots of hyperbolic airtime.

In New York the affiliates sport old favorites, voices of predictive semi-certainty that you can depend on and trust with the inevitability of the now-archaic family doctor. In fact, maybe these TV security blankets, these weather people (and a small army of video medics and consumer omsbudsmen, with their call-ins, write-ins, and displays of sympathetic reciprocity), have inherited the halo of trust that has tumbled from atop the general practitioner's furrowed brow. From Storm Field's alert pertness to Mr. G's name-shortened affability to Al Roker's bubblingly genial smarts, these guys are *really* into it. Genuinely *concerned* with that Siberian Express zooming in from Calgary, frettingly fearful of the storm system forming south of the Keys, disarmingly alarmist when it comes to heat exhaustion, they are a welter of gesture: pointing, panting, pivoting, prognosticating. The forecasters are planted in front of wondrous techno-maps, which transform themselves with holographic grace, and glow

with a kind of cartoony comedic signage: little yellow suns sport shades, threatening puffs of gray cloud wear tiny frowns, moons don earmuffs. Lights flash, arrows beam, and numbers come and go, in a barrage of reticulated fade-outs. All this is then laminated by the forecasters' humble reminders of their fallibility concerning tomorrow's predictions and their contriteness concerning yesterday's mistakes.

Tucked behind desks, the other denizens of the newsroom become talking heads, broadcasting brains, as they report the mayhem and mishaps of "culture." But the weather people tell us of "nature," and are pictured in medium and long shots that show their bodies and tell us about who and how they are in the world. Part Mr. Wizards, part carny schticksters, they nuzzle us with a jumped-up mix of hope, hindrance, and snake oil. Avidly indulging the dispensations accorded the physical world, they carry on a corporeal narrative rife with emotive exhortation and effusive physical language. Escaping the dry simulation of "reason" that permeates news reporting, they obviously take great pleasure in playing the gesticulating body of "nature" to the talking head of "culture."

November 1986

What is it about watching something sour before your very eyes: become old and unmarketable? Seeing this kind of spectacle unfold on TV is nearly revelatory because it's so unusual. Video product tends to either be out of it and old hat at its inception or, because of poor ratings, plucked from visibility long before it loses its bloom or even hits its stride. We are, however, currently witnessing an exception to that rule, a hallowed piece of broadcast product going through a slow and excruciating public disintegration: the fall from grace of the knight of the night, Johnny Carson.

For twenty-five years, Carson's *Tonight Show* has ruled the nocturnal circuits, adorned by a mantle of alwaysness, by the feeling that Johnny was always and will always be there, a smiling beacon guiding our entry into the darkened strait that joins midnight to morn. Of course, this is nothing new. Television has supplied decades of viewers with congenial companions, who are always on time and with whom no appointment is ever necessary. And over the years Carson has been the supplier of a kind of cunning comfort, a guarantor of at least a few giggles triggered by his deft double-taking. This comfort should not be taken lightly, for it was the motor of Carson's reign, of his ability to put us at our ease. But comfort is an amalgam of pleasures and projections that varies not only from person to person, but from generation to generation, and it is in this generational area that the Carson show seems to be experienc-

ing what could be called a crisis of comfort: it is engulfed in a poignantly antic time warp.

The Tonight Show hobbles along in a twilight time zone far removed from Eastern, Central, Mountain, and Pacific, a zone that could only be called Vegas Time: a hermetically sealed rendition of the glory days of show-biz dons, fourth-rate schticksters, and bejeweled mammary kewpies. Ironically, the more Carson becomes aware of the context that contains him, the more he indulges it, hosting burnt-out crooners and airing desperately unfunny skits. Johnny plays the gentleman when cultured "ladies" people his guest roster: the opera singer, the occasional journalist, the "serious" actress—y'know, the kind of dame that lends class to the proceedings. But most of the time, both through his monologues and his lineup, they are the biggest joke of all, taking their usual place as the literalized butts of demi-dirty jokes, the loci of the innuendos submerged in the lascivious exchanges between Johnny, Ed, and Doc. Perhaps the apotheosis of "the Carson girl" was Carol Wayne, whose big-tit/dumb-blond act served as a paradigm for Carson's representation of femaleness. But since her body was found floating off a Mexican beach, Johnny has frantically rounded up a new crew of femme relics.

This tired resuscitation is not limited to sexpots. Going from two-bit actors to gold-chained and sideburned lounge lizard vocalists, Carson is careening perilously close to the short-lived but hysterically riveting *Jerry Lewis Show* of 1984, which in its profound abjection captured the deadness, the rotting stuff, of the show-biz dream. It would be a howl if Carson's show were to drift even farther away from supposedly calculable

demographic demands and to begin to function, like the Lewisian debacle, as some sort of wax museum of outmoded trappings, a kind of zoo for the overcostumed id. Unfortunately, thanks to NBC's purported business acumen and Carson's determination to go out in "high class" style, this crazy travesty will probably not ensue. Too bad.

A cute little girl sits amidst a fuzzy heavenly wonderland, lazily daydreaming and musing, "If I had my way, I'd spend all my day with Ronald and his friends." No, this is not a wish for a vacation in the White House, but rather a burning yearning to kill some time at McDonald's, to trade this woozily gorgeous locale for a seat in some orange plastic meat-palace. Such is the stuff of one of the many scrumptiously spurious commercials that dot the terrain of Saturday-morning TV, making it a veritable meringue of aerated kid-vid, a zappy pitchfest for cereal, bubble gum, robots, cereal, dolls, candy, cereal, and cereal.

The programs between these sticky spots, usually elementary animations that make old Disney stuff look like Leonardo in a slump, tell simple moralistic tales, which are signed, sealed, and delivered in tight ideological envelopes. *The Care Bears Family* is a veritable position paper, a saccharinely preachy manifesto on "caring." "There's nothing like a successful caring mission to make you feel good," oozes one cute citizen of "the Kingdom of Caring." This "have a nice day" domain, however, is fraught with close calls, near misses that threaten to collapse the fur-bundle heaven, where caring is presented not as an ongoing, changing procedure but as an ossified state. Take one of the worldly jolts that briefly interrupt this constant high-caloric intake: in order to punish the Care Bears, a scary villain named No Heart concocts a not unfamiliar scheme—he floods "the Forest of Feelings" and forces its non–Care Bear denizens

to join the Care Bears' closed colony. This overcrowds the bears, causing quarreling and tearing families apart. (Surprisingly, there is no mention of the alien animals taking away jobs from resident Care Bears.)

Following suit, the rambunctious stars of *Muppet Babies* get a lesson from Nanny on the need for rules as she intones, "It's not right to be totally out of control." In response, the "Muppies" raucously burst into song: "We lost control, we went insane and now we're dragging that ball and chain. We learned our lesson and now we know, playin' by the rules is the way to go." Nanny proceeds to give Kermie and the gang a book on democracy, followed by a tour of the nation's capital, replete with visits to the legislature and the Lincoln Memorial. Once again, this treacly lesson is disturbed by the decapitating fact that Nanny's face is never shown. Who is this cropped crusader, drenching the kiddies in pompous pieties? Considering the menu of the A.M. announcements, one wouldn't be surprised to learn that Jeane Kirkpatrick had taken some time off to care for the little tykes.

Recently, however, this paradigmatic, trance-like sugar coma has been thankfully interrupted by a slightly different kind of show, a visual treasure of gorgeous live action dolloped with baroquely adorable animations and hosted by the ridiculously compelling nerd Pee-wee Herman. Not unlike Mr. Rogers, Mr. Herman offers us a meandering view of his turf and of all the neighbors who clutter, visit, and fly through it. Behind a neo-colonial, *faux* tudor, semi-bungalowian facade resides an interior of '50s, '60s, '70s, '80s, zigzag proportions, which is graced by the sporadic visitations of Pee-wee's gang: Chairry,

Conky, Jambi, Globey, Pterri, Miss Penny, the Dinosaur Family, the ant farm, Miss Yvonne, Reba the mail lady, Dixie the trumpeteer, the King of Cartoons, Cowntess (a cow), some kids, Tito the lifeguard, Randy the Puppet, and Knucklehead (a huge hand, which appears at the window and must be the offspring of Señor Wences' act). Eschewing cheap stick-like cartooning and protracted story lines, *Pee-wee's Playhouse* is an amalgam of incidences: a rambunctious chunk of mini-dilemmas, quasi adventures, and corny, jokey play. Pterri the pterodactyl flies in and offers Pee-wee a piece of aluminum foil for his growing foil ball, Conky the robot spits out the secret word for the day, and Pee-wee plays havoc with a salad bar, commenting that "Voilà . . . the cauliflower looks like brains . . . the sprouts look and taste like hair," but still the whole kit and caboodle tastes so "mmmmm . . . salady!"

Pee-wee's Playhouse rejoices in novelty, leaking virtuoso visual effects like a damaged lava lamp. With its mischievous suggestions, sexual ambiguities, and contempo world-weary humor, it is a pleasurable refuge for both kids and adults. But the playhouse exhibits another trait that bears acknowledgment. As compared to the "people who need people," "up with people," empty people of kids' cartoons, Pee-wee shows the actual displacement of caring from people to objects as the motor that makes the world go round. As in *Pee-wee's Big Adventure,* Herman's hit movie from 1985, the playhouse is a domain where *things,* from bikes to knickknacks to appliances, reign supreme. Human beings are *garni,* little extras that brighten up the room. The "Forest of Feelings" is exposed as the scene of a crime, as a site of human exclusion located somewhere on a path be-

tween Ronald's White House and Ronald's Golden Arches. And Pee-wee's place, the result of a zanily serious love affair with domestic interiors, begins to look more and more like some curiously effusive halfway house between a Salvation Army thrift shop and *House and Garden*.

November 1987

The movie screen is a blatant mass of mute chiaroscuro locked in a long shot, a motley interior suggesting lives better left for dead. Suddenly something stirs and the frame is filled with an obstruction: a fuzzy mass of paramecium-like tendencies making mincemeat of narrative figuration. And then the music starts, or some kind of blaring, bleating, jazz-like emanation, as zanily abstract and totally treble as the image it accompanies. This is not some piece of lint stuck in the projector, not a soupçon of art-film technique, but simply the back of a head leaning into the camera: another trick card tumbling from Sam Fuller's crumpled sleeve. From *The Naked Kiss* on, Fuller lets the victims tell their tales. His hilariously droll confections are dolloped with a puff of paranoia that calls every shot and then calls it quits. They are plaintive wails punctured by a flood of ridiculous comedic literalisms. They exude a sort of distanced shame. They are the kind of movies that not too many others could, would, or do make.

There's this thing about movies: their all-too-occasional ability to deliver a measure of pleasurable visual and verbal shift—an unexpected graphic twist, an obtuse kind of camera angle that crosses your eyes and makes you smile, a clump of dialogue that jars you into a recognition of how stereotypical and predictably formulaic everything else you've heard for eons has been. The diminishment of B-movie production in Hollywood has pruned the market of its juice, leaving an acrid patch

of inflated blockbusters and pre-pube eye candy. How ironic that, although largely evacuated from film, a few estimable examples of this lovingly B-type storying are regularly transplanted to television, of all places. There, these semi-extravaganzas make spectacles of themselves again, chomping out a niche in the sci/spy/crime rerun slots that pad the airwaves in the early A.M. Sporting crisply decentered black and white cinematography, both *The Twilight Zone* and *The Outer Limits* are fueled by the economy of their scripting and by their sleazoid exhibitionism. *Secret Agent* and *The Prisoner* couple cloak-and-dagger shenanigans with a quizzically transgressive shooting style, while *Peter Gunn* and, at times, *Mr. Lucky* indulge in a mélange of graphic eccentricity. None of these shows, all of them recently or still viewable on late-night TV, comes close to Fuller's powerfully unenlightened lunacy, but they do share a certain off-putting gloss, a kind of veneered filth that feels real good on the small screen. With its beatnik dungeons and bebop poetics, *Peter Gunn* lends TV a chunky slice of noirish, bizarrish goings-on. Although all these series were the work of many directorial visions, it is no coincidence that *Gunn* and *Lucky* exude the early tackoid humor of Blake Edwards, who produced and supervised both.

Since the days of these black-and-white productions, TV's expanse has melted into riveting color. Clearly the figure who has boosted this chromatic capability to new heights of gorgeousness is Michael Mann, the current descendant of all the aforementioned "authorial" picturing. He has managed a kind of paradigmatic shift in the feel of prime-time picturing, arranging *Miami Vice* and *Crime Story* into a highly designed jumble

of popular history, sexuality, social critique, and drop-dead good look. This is not to overstate his case, to ooze over work already buried in the oohs and aahs of troves of enthusiasts. Mann's acuity is not simply about some fly-by-night gloss but constitutes an attenuated stare at American life. Like Fuller, he's not just wasting time creeping around the momentary symptoms of "cool"—which is frequently how he's viewed. "Cool" is fitting in, but Mann is that rarest of birds: a misfit who knows how to take a meeting. His commandeering brand of video Sol Hurokism has joined the pleasures of the cinematic dispensation (intricate quasi narrativity and a transgressive camera) with the accelerated contemporaneousness of TV. A million knockoffs are in the works.

October 1979

The audience is yelling and clapping, producing an unrelenting wall of sound. Lights flash. "Johnny" is screaming the names of the contestants. "Jane Doe, come on down!" His lungs are scraping, howling this folksy hysterical invitation. Each name is accompanied by a crescendo of surprised "ooohhs" from the audience. The lucky ones assault the stage like a brigade of squirrels who haven't had an acorn for a week. And they are Smiling. They are Happy. They are Thrilled. They are on *The Price is Right*. And perhaps more incredulously they are in "Television City in Hollywood."

"Live from Television City in Hollywood" was the anthematic intro to two decades of CBS broadcasting. It was a charged phrase: a canny combination, positing the velocity of the infant, high-access medium of television, smack dab in the middle of the nostalgic capital of the silver screen.

"Television City in Hollywood" sits in the mind's eye of Americans who are growing up and old with daytime TV. This place, this Television City, is ironically difficult to visualize. It has no corners. It is not made of bricks. It is a city without a mayor or civic center. There is no Elm Street in Television City. It is peopled by handsome emcees with square jaws and nice plaid jackets and blond models with firm thighs, perched on top of mountains of prizes, from diningroom sets to catamarans.

For millions of Americans on thousands of sunny and cloudy days, Television City was a company town which manufactured the stuff of dreams. For an audience composed primarily of women doing custodial work in the home, Television City provided an "out." The space vacated by the actuality of wealth and adventure is appropriated by a riveting, and within our economic construct, lascivious narrative, the story of get rich quick. Just think: *Queen for a Day, The $64,000 Question, Strike it Rich, Let's Make a Deal, The $20,000 Pyramid, The Price is Right.* Television, like the press, understands that "human interest" goes straight to the jugular. The image of a middle-aged woman jumping up and down, wearing a banlon pantsuit with an elasticized waist and clutching a check for $10,000 is surely as charged as a fireman rescuing a puppy from a burning building. These shows vary in what facilitates "winning." Some rely on luck, others on actual skills (spelling ability, word play, and consumer savvy), most being a mixture of both. Interestingly, the few shows originating from New York are usually associated with "intellectual" tendency (memory, word skills, eccentric pockets of knowledge).

But back to *The Price is Right*. The lucky ones are trembling at their podiums, "Johnny" introduces Bob Barker. The audience is awestruck. This really is Bob, striding toward them in a nicely fitted loden green sports jacket. Who is Bob anyway? He does not get old. He gets younger. He is always tan. His interaction with the contestants (I almost want to say patients) ranges from contemptuous condescension, "I need your answer NOW Loretta," to guarded praise, "She's quite a shopper."

The game begins. Buzzers sound, bells ring, lights flash, walls go up and down, music stops and starts, tables are wheeled in and out. The demi-triumph of facade technology. Things made of orange and chartreuse cardboard, light bulbs, and extension cords almost come off as the machines and computers which they pretend to be. Then there are the prizes. A pink wall sporting a huge dollar sign mysteriously rises, exposing a model in a baby blue chiffon dress who is caressing a gigantic refrigerator. She opens the appliance, removes a can of corned beef, and begins to fondle it. The camera moves in on her long red nails lightly stroking up and down, up and down the length of the can. The winner, Peggy, who has just "bid the highest without going over" jiggles up to the stage. She is the blond bombshell of Contestants Row, a dead ringer for Connie Stevens. She runs up to Bob, a tiny doll clutched tightly in her hand. She tells him that her lips are chapped and she can't kiss him, so she brought the doll along to plant a little peck on his brown leathery cheek. Cute. Bob graciously accepts the doll's affection and asks Johnny to unveil the next prize. The wall quickly rises and Johnny is beside himself. "A NEW CAAAAR!," he screams. His bellow is shocking in its intensity, the end of it almost tinged with a sob. At the sight of the car, the audience, which has been waiting for this prize of prizes, issues a looming, resonant hum signifying an awe usually reserved for the landing of a mothership. Peggy, doll in hand, jumps up and down, her pink mouth frozen open, as if issuing some inaudible high frequency bark. A model in scanty shorts is sitting on the fender of the car holding a sign that says "Ford."

The show goes on. New contestants win and lose. Reaction shots of friends and lovers tell us of affiliations. There are no "loners" on *The Price is Right*. Richard Speck and Arthur Bremer have never won three-piece livingroom ensembles, chrome and formica bars, unicycles, or shag rugs. This litany is a dictation to the viewer on the curative powers of inanimate objects.

If the game's scenario illustrates the production of lack through the promise of a secondary other (objects, goods, machines), then the commercials which puncture the game (or visa versa), introduce lack as this secondary other's attributes. Stain and smell are code words. Clothes, glasses, toilet bowls, and teeth are stained. Rooms, underarms, genitals, and breath smell. And the body is responsible. The vulnerability and maintenance of the body is clearly a liability compared to the smooth hum and unyielding surfaces of appliances and Pintos.

Johnny announces another prize. "A fuur cooaat!" The audience is screaming again. On the screen the model is buried in a huge, black fuzzy thing which looks like an acrylic bathroom rug. She is stroking herself and wrinkling her nose. The lights behind the model gleam like diamonds and the area surrounding her is blurred, creating a nebulous rainbow. This tiny furry figure adrift in blue and pink fog is someone's idea of heaven. The effect is one of comedic aura, but in Springfield, Ohio, a thirty-eight-year-old woman pours a second cup of coffee and stares at the television screen. She is not laughing.

Remote Control:
A Film Treatment

Remote Control is a gathering of semi-stories, clumps of characters and situations which tell tales about a culture ruled by images. It is about the forces which regulate from a distance, which eschew the specificities of history and the concretion of the body and collapse all into the silent but unrelenting rhetoric of the image. It is about politicians, journalists, television, families, and filmmakers. It is not about what and who they are, but rather, how they are constructed through pictures: what they represent and how they are represented. What defines *Remote Control*'s difference from most of the moving pictures that surround us is the pleasure it takes in interrupting the muteness of picturing with a seriously playful display of language. This insistently seductive speech baits the communicative force of the image, pressing it to expose its implicit meanings and agendas and allowing the film to give voice to a commentary both critical and comedic.

Remote Control is constructed via a trio of narratives which appear in episodic alternations, each beginning with an eight-minute establishing section. As the film progresses, these sections shorten and the alternations quicken into slices, creating a kind of fluent visual shuffling and channel changing. This trio is then signed, sealed, and delivered via a fourth section which shows how these particular pictures and words are arranged to produce the movie which you have just seen.

The first establishing section follows a politician on the campaign trail. Like good spectators, we watch and sometimes listen to speeches and check out the crowd. Through a somewhat langorous frenzy of sync and non-sync sound, slow pans, reaction shots, and a persistent talking head, we watch pose gel into stereotype and become anthematic of "integrity," "morality," and the discourses of "the truth." Through this initial section and the glimpses that follow, we get a potent dose of podium logic, boosterism, and rhetorical cliché as we see the candidate work the crowd and press the flesh. We follow the bright-eyed hopeful into town meetings, down the aisles of airplanes, up stretches of freeways, and, most importantly, on television.

This regard for television sets the scene for the second establishing section which develops a commentary on how TV journalism determines electoral outcomes. A TV journalist is on the trail of the candidate. He scrutinizes situations, frames gestures, and transforms them into events. His program director further condenses his efforts, aligning them more precisely with the reductivist tendencies of broadcast TV. We observe TV as it transforms people into personages, ironing out the complex pleats of the social into a flatly fragmented continuum of demi-associated moments. Indulging in a kind of high-tech private-eyism, reporters search for spilled beans and hot tips, mixing serious investigative activity with blatant career building and self-interest. This section and its unravelment considers television's impact on the notions of fact and fiction: how it distributes power, creates "reality," and makes history.

The third establishing section focuses on the audience, honing in on a family enmeshed in the spectatorial space of the world's favorite piece of talking furniture. In many ways, the image of clumps of bodies clustered around the electronic hearth has served as a kind of paradigmatic view, a muted domestic pastoral which begins to describe the feel of life in the second half of the twentieth century. *Remote Control*'s use of this domestic portraiture not only shows the pleasures and skirmishes of shared viewership and commentary, but also focuses on how the interiority of the home and the quasi-family unit function as target sites for perpetually acquisitive electronic transmissions. Indulging in relentless direct address, constantly exhorting and always on the make, television seems awash in a wildly compensatory frenzy, trying to make up for the lagging social relation of its audience. Its fascination, its riveting murder of response, reassures its viewers that social reciprocity is a boring archaism which went the way of last season's sit-com and yesterday's made-for-TV news crisis.

The fourth and final part is a single establishing section which glimpses into the construction of film itself: at how the ideological determines representation and visa versa. As the director sits at the editing machine, we look and listen as she and her colleagues discuss how images signify and meanings emerge. Their commentary both engages and veneers the editing process which arranged the images which we have just seen, foregrounding the machinations of framing, substitution, addition, and subtraction. Pictures are paraded and slowly scanned, praised, scorned, and put up for grabs. Scenes are inserted,

juggled, and omitted. Sound is synched and voiced-over, hushed and amplified. Characterizations are dulled or exaggerated, facial expressions measured, and body language stressed or contained. This final section suggests *Remote Control*'s status, not as an object, a decorous closure called a film, but as an active, rangy process which partakes of both the white-light rigor of critique and the comedic, shinily seductive narrative play of the movies. *Remote Control* will play around with pictures and stories: stories of the generic posing and talking money of politics, of the almost viral flow and powerful aerosolic capabilities of television, of the symptoms and conditions of viewership, and of how we make movies and movies make us.

1985

Moving Pictures

Virtue and Vice on 65th Street
New York Film Festival

The notions of vice and virtue function as traditional motifs throughout the history of film production. This duality is most apparent when characters emerge from "opposing" corners—but the incorporation of stereotypical dualities within a single character engages more ambitious complexities, especially when that character is a woman. For while a man's fall from grace can prefigure a broad field of possible transgressions, the woman's temptations are inevitably linked to her sex and how she wears it.

This good/bad motif was entertained by a number of films in this year's New York Film Festival. Michaelangelo Antonioni's *Identificazione di una Donna* (Identification of a Woman) pictures a man obsessively riveted by what he sees as the moral mutability of "the fair sex," while Cecil B. DeMille's *Madam Satan* foregrounds its heroine's appropriation of vice to redeem her virtue. Joseph Losey's *La Truite* (The Trout) employs the notion that sexual repression is a girl's ticket to ride. And finally, Rainer Werner Fassbinder in *Bolwieser* (and in almost all his other films) suggests that sexualities are not random spurts, but the results of highly manipulative social constructs. I will preface any further comments by noting that the depictions of vice and virtue in these films are, of course, determined by the libidinal economies and sexual proclivities of the men who have directed them.

Identificazione di una Donna is Antonioni's first film in 18
years to be set in contemporary Italy. A more appropriate title
would have been "I Am What I Am: Me, Myself and I."
Niccolò, the hero (Tomas Milian), is a middle-aged film direc-
tor searching for both a girl friend and something to make a
movie about. "You're unfathomable. You manage to be smart
and stupid, good and bad, bitter and sweet," he coos to his girl
friend of the month. He is looking for his ideal, "[a woman] to
be quiet with . . . as with nature," a woman whose poeticized
alternation between good and evil works not to disrupt his
assumptions but to neutralize her presence; a woman whose
franchise is her exoticness, the apex of which is her absence. But
the next best thing to her absence is her objectification. And
Carlo di Palma's flawlessly gorgeous cinematography assures us
this view with an elegant constancy.

Mavi (Daniela Silverio) is the first of Niccolò's girl friends
to appear. She is a rich young woman easily seduced by pouting
men who think they're intellectuals. The couple makes leadenly
pretentious conversation in lots of different houses with nice
furniture. He is usually dressed and she wears underpants with
nothing on top. Her family soon removes her from his clutches.
His next girlfriend, Ida (Christine Boisson), looks like Mavi but
has a bigger forehead. She is a young actress rebelling against
her privileged background, and sporting a well-practiced swag-
ger which is supposed to indicate an aggressive independence.
Niccolò provokes her with his whining nostalgia for Mavi,
while she tells him that horseback riding excites her sexually.
They sit in boats on deserted expanses of water and say the word

"solitude" repeatedly, but most of the time they sit in modish rooms, he dressed and she in underpants with nothing on top.

The film is a sluggish parade of elegant assignations and stylish brooding. Niccolò paces his cute little villa and stalks pretty young women like Portnoy on leave in the Mediterranean, in search of the perfect seminal receptacle. Instead of critically viewing the notion of the female "ideal" as it perpetuates the fiction of women's sexuality, Antonioni projects the fictive as the representation of the actual. The exclusion of women from subjectivity is replayed in stunning fashion, substantiating the notion that all of woman is fugitive (goodness, badness, speech, etc.) except the silent stereotypical figure that settles the male gaze. And any ironic content in this film has been swallowed by the powerful overture of its original model, that of a tantalizingly seductive bourgeoisie. Amusingly, the film's closest connections are not with the formidable bastion of Euro-intellectual art cinema, but with *Emmanuelle,* Just Jaeckin's soft-core exposition of Sylvia Kristel in underpants with nothing on top. *Identificazione di una Donna* identifies only Niccolò, the troubled but well-appointed mope who suffers from the top of his head to the tip of his cock. It is a film about buttocks and beautiful real estate. And, of course, women and houses do share a similar function in that both can be the elegant repositories of what men consider to be their capital.

If *Identificazione di una Donna* excels at the close-up scrutiny of the female body and of its use as a vehicle of deliverance beyond good and evil, then DeMille's *Madam Satan* is a long-shot display of humorously explicit sexual spectacular. Made in

1930, it tells of Angela (Kay Johnson), a wealthy socialite, and her efforts to lure her husband Bob (Reginald Denny) away from the charms of Trixie, a song-and-dance girl (wonderfully portrayed by the young Lillian Roth, ironically the author, many years later, of the sad *I'll Cry Tomorrow*). In the face of her husband's sexual philandering the good wife understands that her masochism necessitates an infinite resilience, and when her martyrdom begins to wear thin, she borrows the costume of vice to fight fire with fire and win back her man. She attends a masquerade on a dirigible dressed as Madam Satan, a wily, provocative vamp, and makes Trixie, her rival, look like Rebecca of Sunnybrook Farm. Madam Satan is hailed the belle of the ball, thanks to her sophisticated form and oblique promises of dirty delights to the salivating men who surround her. Bob falls in love with her, innocent of the fact that this tempting morsel is nothing more than his glacial wife, the one he had dismissed as "above all women and below zero"—the virtuous woman he didn't desire. Angela realizes her newfound position of power, and before unmasking herself tells Bob that she will give herself to him only if he wipes out the memory of all other women.

Madam Satan is an interesting combination of Victorian didacticism and saucy drawing-room farce. While predating the golden era of the screwball comedy, its fluid dialogue (written by Gladys Unger and Elsie Janis) carries intimations of the coming genre. Not surprisingly one of the film's art directors, Mitchell Leisen, later went on to direct many of Paramount's smoothest comedies. DeMille couples this literate, witty style

with the density of the extravaganza, culminating in a stunning dance sequence aboard the dirigible, a baroque compendium of *Metropolis,* Busby Berkeley, and Oskar Schlemmer.

The film features intense male bonding, allowing Bob and his friend Jimmy (smartly depicted by Roland Young) to drunkenly sing together, play together, shower together, and even go beddy-bye together. Angela is denied camaraderie with other women, the sole exception being her maid, who hardly shares a relationship of reciprocity with her boss lady in this dream world of spectacular expenditure. Trixie and Angela are linked only through their rivalry over a man. This competition is later broadened to include a beauty contest, which Angela/Madam Satan, as the simulacrum of evil, wins hands down. All female concern, all strategy, lies in securing the figure as the pose that rivets the gaze, and the women are willing to juggle the accoutrements of vice and virtue to achieve their ends.

Where *Madam Satan* argues for the relinquishment of pleasure as the price of virtue, *La Truite* focuses on repression as a sexual stimulant—on the power invested in refusal. Directed by Losey and based on the novel by Roger Vailland, it portrays Frédérique (Isabelle Huppert), a woman who uses sexuality as an instrument of aggression, plundering and accumulating profit along the way. From the secret club of her teenage years where she and her girl friends pledged to get things out of men without giving them anything, to her current circuitous antics, she is defined by a confluence of virtuous denials and purposeful calculations. She understands the economies of capitalism on both a numerical and a libidinal level. She is currency. She choreographs her way from a trout farm in the Jura region of

France to the high echelons of multi-national corporate dealings. And yet Losey depicts her not as an ambitious, forthright woman but as a blank child, implying that her exploitative demeanor is not a learned exercise but a "natural" function of her gender. She walks around in short skirts, drinking milk and saying things like "I'm afraid of nothing . . . I'm never tired . . . I'm never hungry." These coy declarations are not issued together, of course, as this might have an overly aggressive quality. Rather, they are released separately in quiet moments, like treasured little pellets of shit. And those who understand this rhythm of retention and release never underestimate the perfection of the appropriate moment. Frédérique mixes prepubescent sexuality with a trance-like denial of the goods, and her rise to power can only attest to the successful consequences of this behavior.

Frédérique is at home in the world of men and their money, whether she is jetting across the globe, daintily slumbering with her head on some mogul's shoulder, or inhabiting the fancy hotels of the international capitals. In Tokyo she meets a "woman of the world" who boasts of having "made love" over 33,000 times (to rich men only), claiming that the sense of sin gives her great pleasure. Though sex seems to be gratifying for her, Frédérique's real pleasure lies in her denial of the genital function—a virtue whose economy seems to lie in repression. While the refuge of denial could be an apt position when one is intent on extracting vengeance for past humiliations, Losey is simply not up to the task of dealing with these libidinal methodologies. His supposed indictment of sexual strategy and the preponderant characteristics of multi-national capitalism reads,

instead, as a toney homage to the good life, and his naming of Frédérique as the prime mover who perpetuates the extremities of the sexual contract might very well be his deluded idea of a happy ending.

The speculations in feelings and false universalities that mark all these films were always areas well scrutinized by Fassbinder. Although his films entertain melodramatic strategies within a relatively traditional narrative structure, he cannily utilizes the power of these overtures without being subsumed by their conventions. His handling of so-called "moral issues" like vice and virtue never dissolves into stereotypical reification of dualities, but rather is complicated by his recognition of the social organizations that instruct our desires.

Bolwieser was produced for television in 1977 and has since been reedited for theatrical release. Adapted from a novel by Oskar Maria Graf, it is a florid recounting of the pleasures and self-deceptions of lower-middle-class life in the Germany of the 1920s. Bolwieser (Kurt Raab) is a passively plodding stationmaster whose wife, Hanni (Elisabeth Trissenaar), is bored by her isolation and provincial surroundings. Pictured as a beautiful and lusty doyenne of the interior, she patrols her domain (the home), straightening bric-a-brac, preparing meals, and grooming her body. Like every other woman on the block, she is inside waiting. She begins a series of affairs knowing that her beguiling manner will calm the suspicions of her gullible husband. Eventually her trysts are discovered and result in a scandal which is soon brought to court. In defending her, Bolwieser, who is desperate to recuperate his hallucination of their marital bliss, is indicted for perjury and sent to jail.

Almost none of the players in this film are characterized as either good or bad. Their power-mongering and gossiping are presented as symptomatic of the economic and psychological tendencies that shape their social lives. Hanni, even though she remarries while Bolwieser is languishing in prison, is not punished by the scenario. Her sexual candor is not viewed as a fall from virtue, but merely one of a variety of ways that people employ to both pleasure and brutalize one another.

In 1856 Gustave Flaubert was tried and acquitted of having committed outrages against public and religious morality and decency. The charges resulted from the publication of *Madame Bovary* in serial form in the *Revue de Paris*. This tale of a woman's fall from grace in 19th-century France inflamed its readers, who were already addicted to a habitual diet of serialized novels. Today, the delivery of these fictions is carried on by the medium of television. It is well suited to the rhythmic unraveling of events, rife with emotional crescendos and the condensed, magazine-like procedures that we call soap operas. So it seems appropriate that Fassbinder, whose work has been dismissed by some as "petit-bourgeois soap opera," on occasion embraced television as a vehicle for the broadcast of his work. And *Bolwieser* is not far removed from the misbegotten maneuvers of Flaubert's Bovary. However, where much television production is still rendered via strangely static, theatrical long shots, *Bolwieser* is coated with close-ups which enhance the "up close and personal" qualities of the medium. And unlike the cascade of parallel action which comprises the soap-opera style, Fassbinder's depictions have a slower, more singular quality, drawing on a specific dramatic arena rather than on a chorus of

duets attesting to moral guilt or innocence. He positions the spectator in such a way as to be vulnerable to the empathetic device while still able to objectify its machinations. Interestingly, this description of Fassbinder's working procedures, this sense of near and far, is not unlike Charles Baudelaire's description of Flaubert's portrait of Madame Bovary: "To be as capable of calculation as of dreaming." This suggestion of a relatively free field could also apply to Fassbinder in his interest, not in the naming of vices or virtues, varieties of sadism or masochism, but in the ways in which we comply with or resist the clichés of our own destruction.

1983

The Man Who Envied Women
Yvonne Rainer

"I've never seduced a virgin or intruded upon a valid marriage," declares a man who admits to the gentility of his social relations. "You can ask me about the peculiarities of my shit, just don't ask me how much money I have in the bank," confides a man whose discretion extends only to his finances. "It's possible to have the whole story of Oedipus playing in your head and still behave properly at the dinner table," suggests a man with more than a soupçon of analytic grace.

Who is this man who appropriates and dispenses wisdom with the aplomb of an encyclopedia salesman, who collapses upon the altar of learning like a Rosicrucian floored by the Enlightenment? He is Jack Deller, the focus of a new film by Yvonne Rainer and, as the title declares, *The Man Who Envied Women*. He is portrayed by not one actor but two (William Raymond and Larry Loonin), who embody this mass of doubled trouble with the self-betraying rigor he so rightfully deserves. But what's his story? Well, according to Rainer, Deller's an academic kind of guy whose class lectures zigzag between interminable rhetorical mimicry and desperate, anecdotal accountings of his brushes with greatness, his demi-acquaintances with the authors whose words he mouths.

But what about those envied women? Where are they? Although women do appear on the screen they are mainly heard, not seen. They are represented by their voices, which encircle Jack and his musings with a daisy chain of acerbic

commentary and tragicomic confessionals. One of the voices belongs to the woman who has just ended a five-year relationship with Jack, and it is her no-nonsense but nonsensical voice-over that holds court over much of the proceedings. Sharply ridiculing Jack's womanizing, she suggests that his theorizing is just another weapon in his arsenal of conventional seductions. Jack, meanwhile, sits in front of a backdrop of old movies, or walks down crowded streets to overhear knowing women give him and his ilk the once-over with joking ease. While his own speech is a folding together of swipes from Michel Foucault and Raymond Chandler, and much in between, the entire film looks a bit like an elaborate marriage of Jean-Luc Godard and Paul Mazursky (honeymooning in TriBeCa). Thankfully, the nuptials are interrupted by Rainer, whose rendition of the self-adoring, intellectualizing, pussy-chasing, pontificating, self-pitying male kvetch puts everything into a wisecrackingly ridiculous perspective.

Jack and his detractors constitute only a portion of the film. The rest is divided into other slices of life, from the struggle for a chunk of Manhattan real estate to a scrutiny of America's machinations in Latin America and a consideration of the power of photography, advertising, and journalism; from the issues of women and aging to a questioning of the effectiveness of theoretical writing. But this scrutiny of theory seems weird, and it's a different kind of weirdness than Rainer's usual mix of quirky irrepressibility and pleasurable ambiguity. Something else is at work here that allows Rainer, who usually skirts the traps of damnation and paranoia with aplomb, to indulge in a tensely poised reactive mechanism that can easily be appropri-

ated by those whose relationship to theory is stalked by intimidation. Her suggestion (through the reenactment of texts by Foucault and Meaghan Morris) that theory is a discourse grounded in an oppressive, univocal mastery should definitely be considered. However, it should also be remembered that the master speaks in many tongues, one being that which fears theory and the commentary that arises when language turns back against itself—when it baffles, juggles, and outplays the constructions and declarations of power. Rainer's scrutiny of theory is not a call for rampant anti-intellectualism, nor is it a witch-hunt that views ideas as unstaplers of one's own power, whether that power is wielded in legislative committees, on the battlefield, or in the pages of art magazines.

The Man Who Envied Women, like most of Rainer's films, is always "ostensibly" about something. In other words, it engages models of juxtaposition and selection that reveal what *might* be the film's "real" engagement as opposed to what it proposes as "real." Doubling and tripling characters, disheveling tableaux, and pillaging stories, Rainer disperses the cinematic illusion of "reality" into a shower of possibilities and ostensibilities. Playing the game with the canniness of a card shark, she shuffles the deck, bilks a few suckers, and reminds us of the shifty base of "value," whether it defines sexual relations, real estate, or human life. Rainer is not trying for some kind of well-mannered correctness or a masterly, fatherly notion of "transcendent intellectual clarity"; rather, she tends toward a type of tumbling process, an unbalancing of power, language, and the body. Avoiding goals, she cheats the conventions of realistic narrative and makes a mockery of masterly language.

The Man Who Envied Women exudes a profusion of verbiage that is funny, brave, rude, and benevolent. The masters can make of this what they will, and some of us will continue to provide their lofty inabilities to grasp the goof with an accompaniment of knowing laughter.

1986

Territories
Isaac Julien

Passion of Remembrance
Isaac Julien and Maureen Blackwood

Handsworth Songs
John Akomfrah

The Workshop Declaration emerged in Britain in 1981, giving support to non-profit media production units. These workshops function as community focal points for education and training and produce media projects not possible through commercial channels. Sankofa Film/Video Collective and Black Audio Film Collective are two of the workshops which emerged through this moment of racially sensitive cultural policy.

In *Territories* (1985, directed by Isaac Julien) Sankofa tries to deal with how the look, the city, and the body are territorialized within the social field. Focusing on the site of "carnival" (which is usually viewed uncritically as the apotheosis of Afro-Caribbeanism), the film shows us how this event is framed and named as an arena of transgression: as a leakage of the unseen and the unspoken onto the stage of civil society. Prefacing much of the "action" is a voice proclaiming "This is London, BBC World Services," a staticky radio annunciation which could emanate from around the corner or around the world and carries with it the framing eminence of empire. It introduces us to a chain of images: aerial views of rotting cityscapes, syncopated paraders, gay couples, burning flags, and white cops busy surveilling and crowd controlling. A frantic soprano voice sirens around the images creating a tug of war between pious folkloric infusions and righteous signs of rebellion, around carnival's alternation between alleviation and a so-called excess which in-

vites the state's totalizing control. Functioning as a revved up and down meditation on "Who I Am," *Territories* carries voices that question their place in the colonial catalogue of givens and foreground the contradictions between so-called self-images and prescribed images, between "us" and "them," between autobiography and ethnography.

In *Passion of Remembrance* (1986, directed by Isaac Julien and Maureen Blackwood) Sankofa looks for the place of sexuality amidst the prioritizing of black identity and nationalism, and tries to skew the surety of the clenched fist as signage: to loosen up what can be seen as the machismo implicit in this body language. Divided into urban and landscape sections, *Passion* focuses on the black family, showing us the Baptiste clan glued to a TV game show featuring a young black couple as contestants. As her brother criticizes their performance, his sister Maggie suggests that "Every time a black face appears we think it has to represent the entire race. We just don't have the space to get it wrong, that's the problem." And this problem is dealt with in a wave of episodic passages: brown bodies splash through a crisp aquamarine pool, diagonalized aerial views of demonstrations dissolve into a kind of image-processed phosphorescence, guys have heart-to-heart talks, girls try on earrings, all of which is spliced and edited within a rhythmic container of powerful musicality. In fact, it is this musical accompaniment which sets off one of the film's finest visualizations, a to and fro between rooms in the family apartment: one holding two young women preening to party to the backbeat of rock while their father and brother dance and story out to the time-tested pleasures of calypso. This dueting is even more

prominent in the film's "landscape" segment, in which a young woman and man perch in a canyon a million miles from nowhere and angrily debate the problem of finding one's way "home"; of getting around a system which "lives our lives for us." This enraged tussling powerfully foregrounds the debates around nationalism, identity, and mastery which have arrogantly foreclosed a consideration of gender.

In *Handsworth Songs* (1986, directed by John Akomfrah) Black Audio attempts to interpret the 1985 Handsworth riots by asking many questions through many voices: How is one enfranchised? How does one buy into the social contract? What is England? Echoing throughout the film is the statement "There are no stories in the riots, only the ghosts of other stories." With this, Black Audio suggests that explanatory accounting, the spine of conventional reportage, produces a singular depiction of "truth," whereas events are actually a conflation of multiple framings, readings, and sightings. Purporting to "scrape the bottom of the barrel of British archival memory," *Handsworth Songs* sports old newsreels from a 1939 Labor Day demonstration, oblique shots of statues commemorating the heroes of exalted Anglo history, a chorus line of cops crouching behind bullet-proof shields, an old interview with Lord Gibson, the "King of Calypso," talking heads of blacks and Asians speaking of the symptoms and causes of the riots, and footage of photographers frantically scavenging the funeral of a black victim of the disturbances.

The beginning segment of the film is repeatedly interrupted by the image of a laughing mechanical clown whose churlish grotesqueness punctures this parade of pictures and

functions as a kind of ludicrously ironic concretion: a residue seeping out of the force field of anger which is constructed and perpetuated through the image repertoire of a culture. *Handsworth Songs* puts into question the discriminatory power of these images and their ability to emblematize both "empire" and "black threat." It shows us the war of naming the problem, of assigning the blame, of renewing the exclusion of the excluded. Black Audio seems to prefer working in a hybrid manner, packing their bags with bits of Foucault, psychoanalytic theory, Afro-Caribbean discourse, and colonial and neo-colonial narratives. They are insistent in their critique of the binaryism of the negative/positive image riff which has frequently been the limit text of much work concerning "otherness" whether it is race and/or gender based.

Both Black Audio and Sankofa address head on the assumption that the power of black expression *must* reside within an oral, performative tradition which can limit the project of black subjectivities by privileging the said over the seen. They are attempting to break down the conventions of what is "appropriate" black visual production, be it filmic or an art object, and are trying to put into crisis the possibility of "telling it like it is." Working the space between the clichés of Euro-centric theoretical language and black "plain talk," they question both the demands of social urgency and the seductions of an empowered image culture.

1988

American Pictures
Jacob Holdt

In this era of rhetorical inversion it is no coincidence that an administration engaging the rallying points of religion, bootstrap individualism, and bodily fitness in fact works to elevate intolerance, undermine civil rights, and accelerate the pollution of the food chain. An unrelenting shower of sloganeering to exalt "optimism" and a fuzzy, unspecified notion of "the future" have enveloped the American spectator in a calculated frenzy; the intent is to erase "gloom and doom" from the public eye—to preserve the nation's fertile fantasy life.

One project countering this effort is *American Pictures,* a filmic slide show exposing the very images that the powers that be have worked to render invisible. Jacob Holdt, a Dane, spent five years hitchhiking or "vagabonding" across America, living with some 350 families and amassing a collection of fifteen thousand photographs which powerfully attest to the presence and sufferings of the other America—those who neither learned the ropes at Bechtel nor barbecue at the Ewing ranch. The film is divided into two sections, rural and urban; this first part focuses on the horrifying discrepancy between white and black, rich and poor, in the rural South. What Holdt sees affirms his belief that slavery is not only a tragic historical event, but an institution that still thrives today, supplying the labor force for America's sugarcane and tobacco plantations and guaranteeing the nation's fluency in the language of violence. We see photographs of black people subsisting in ramshackle shanties with-

out electricity, heat, or running water, eking out lives on diets of turnip greens and sweet clay; simple household amenities are as foreign to them as the availability of a good education. For, as Holdt puts it, "thousands of people in America still live by the light of the kerosene lamp," which burns only when they can afford to buy fuel.

American Pictures is a powerful presentation of the sufferings of rural black America, but there are a number of flies in this ointment, two of the biggest being the problematic nature of the documentary-photography genre, and Holdt himself. His unrelentingly naive voice-over coats the images with the optimistic platitudes of the hippiedom so available to white, upper middle class Americans and Europeans during the '60s, and suggests that the subject of the film is not the mean extremities of black and white America, but the messianic convictions of our poor, righteous, beleaguered hero. He tells us that he "throws himself into the arms of those who need him," and reminds us that "Americans are very aggressive sexually"; we discover that practically all the people he meets, men and women, rich and poor, black and white, just can't seem to keep their hands off him. And he gives in to all of them because first, it's part of his "yes philosophy"; second, "all you really need is love"; and third, he's just the darndest, most benevolent stickman you'll ever hope to meet. He speaks of the needs of these love-starved people, but of course the needs at issue are also his own: to make a "far out" escape from the unimpoverished white doldrums of Denmark into what he views as the black netherworld of America, the belly of the beast of the "white mother culture" (so much for the law of the father) where he

can "learn more in one night with a black prostitute than in four years of university."

The film is rife with this kind of sloppy sexism and racism, and its pronouncements on the black family echo Daniel Moynihan's conservative "melting pot" report of 1963. Holdt thinks he is outside society, but in fact his presence amidst the poor is very much felt and occasionally results in tragedy. His living with a young black woman, for example, precipitates the burning of her home and the death of her brother. She pays a painful price for Holdt's picaresque adventuring while he gets some "great" photographs out of the incident. Holdt is ambushed by the Klan, protests at Wounded Knee, has numerous brushes with the FBI and the Secret Service, and supports himself by selling blood twice a week (perhaps to help literalize the game plan of a vampire culture?). Indeed, things sometimes get just too heavy for our randy crusader, who admits that "vagabonding is an overwhelming experience and after a while it was necessary for me to stay with the rich for a while so I could have some peace of mind. . . . But always when I was the most down the most fantastic things would happen." Like getting picked up by millionaires and staying in extravagant antebellum mansions, rounding out the recipe with a pinch of master and a pinch of slave. This economic and sexual tourism, this uncritical transition from picturing into the picturesque, is the motor of *American Pictures*.

Nevertheless, the film (which was originally a book and a slide lecture) *is* a graphic outline of how blaming the victim perpetuates the misery of the poor and how "massive bourgeois propaganda makes people act against their own best instincts."

It is the kind of work that one hopes will encourage less reductivist projects intent on showing and saying what is hidden in our corporate economy. It reminds us that no amount of media special effects can efface the racism that divides America, and also that the most well-meaning intention can enlist the most exploitational devices to make its point and procure its pleasure.

1984

Virtual Play

Steve Fagin

Her face adorns the cover of a book. She wears a direct gaze, adamantly askew hair, and a full, welcoming mouth, all of which are framed by a fur collar. The book is *The Freud Journal of Lou Andreas-Salomé* and it is she who covers it. The blurb beneath the title reads, "A fascinating glimpse at Freud and his circle in the early years of the twentieth century." So Lou Andreas-Salomé is the one who glimpses, who (according to Webster's definition) gives us faint, passing appearances or inklings. The glimpse is that which shines unsteadily; the intermittent glow and not the beacon. The glimpse is never anthematic like a fixation and lacks the insistence of a stare or the lasciviousness of an ogle. It carries the interrupted enlightenment of a distant source. So it is not surprising that when Friedrich Nietzsche met Lou Salomé he asked, "From what stars have we fallen to meet here?" To a star-struck Nietzsche, Lou Andreas-Salomé played the intellectual and sexual adventuress. She privileged the "erotic hour" and women's ability to allow for physical affection. The psychoanalytic writing of the last third of her life ranged from papers on feminine sexuality and anality and sexuality to her most celebrated work, "The Dual Orientation of Narcissism." She seemed intent on mixing intellectual activity with the enjoyments and disappointments of daily life, or better still, to see these not as separate arenas but as pieces of a single cloth. But history provides us with a more lopsided reading of her life, recording less about the weight or lightness

of her intellectual work and more about her role as muse and desired object to a generation of "great" and not so "great" men. She seemed to be their locus of exchange, a charming conduit and, of course, a great listener who dispensed "feminine intuition" with a kind of juicy grace. She broke Nietzche's heart, was Rainer Maria Rilke's "older woman" and Freud's confidante.

This description of Lou Andreas-Salomé as the focus of a particular type of male attention brings us to *Virtual Play: The Double Monkey Wrench in Black's Machinery,* 1984, a videotape by Steve Fagin. It is about Andreas-Salomé in that it places itself in various positions around her figure. These can be read as segments—viewings that vary from truncated soap operas to touristic slide shows to lessons on how to cook a chicken and build a dollhouse (just to name a few). The images are blanketed with a sound track that jumps from speech to song and forms a generally rich kind of ruckus. Rather than constructing a rigid chronological narrative, Fagin's surrounding views range far and wide and join the eloquences of the tableau with the elementary clarity of the comic strip. Two hats bob atop some chair backs and we realize that we are watching and hearing Lou (Jeanne Wolf Berstein) and Anna Freud (Jutta Collins) recount stories about Freud's pet dogs and a narcissistic cat. We see Lou cozying up with the young Rilke, and, in one of the most effective segments, we watch her engage in an astutely zany bilingual conversational duet with Elizabeth Nietzsche (Ingrid Edgers). This scene, like many of the others, focuses on language and how it asserts or effaces notions of fact and fiction, clarity and confusion. Other moments offer lectures on the early uses of

photography. Tales of terror emanate from telephone answering machines, and a semiotician and an anthropologist puzzle over the reaction of a group of "natives" to a film.

Fagin has concocted a "creative" conglomeration of psychoanalytic theories, biographical snippets, Syberbergian expositions, and calculated child's play. Although things sometimes collapse into a self-congratulatory and needlessly protracted parade of visual fluencies, Fagin fortunately avoids the rigid dictations and blind pomposities of theoretical illustration. The richness of the work allows it to offer viewings and readings on a number of levels, from pleasurable visual dexterity to gossipy verbal admission to the decoding of rebus-like textual formations.

But *Virtual Play* could also be called a congregation of quotations and effects. And perhaps the word "congregation" is an unfortunately apt one since an air of religiosity seems to pervade the entire affair (or affairs). Fagin approaches the woman he believes to be Lou Andreas-Salomé with a rote determination: she becomes muse-like, literally the veiled Salomé, a richly segmented and constructed object which he articulates with the finesse of the fetishist. *Virtual Play* is around and about Lou Andreas-Salomé but she is really beside the point, because the tape's subject seems actually to be Steve Fagin and the association her figure might activate between him and the "great" men who have gazed at her picture, whose words have fallen on her lovely ears, whose hands have touched the adamantly askew hair that floats above her fur collar.

1985

Insignificance
Nicolas Roeg

The current spate of kid movies and grotesque patriotics has been momentarily interrupted by a film in which Marilyn Monroe and Albert Einstein meet in a hotel room. Most movies use the cartoon stereotype as a reductivist device, removing the rich pleats of meaning and consolidating all information into the economy of myth. Nicholas Roeg's *Insignificance* (1985) unfolds these singular mythologies and exposes the stuff that comprises our notions of history, nationalism, and biography. The film combines the solidity of fact with the diffusion of fiction and turns the singularity of "significance" into the multiplicities of the "insignificant," dancing around the surety of knowledge, beneath the repressions of surveillance, and within the envelope of the ideological.

The film opens with the image of an actress (Theresa Russell), unnamed yet undoubtedly cast as Marilyn Monroe, straddling a sidewalk grate, her dress billowing around her like a rambunctious lily pad. Two film technicians crouching beneath the grate operate a fan that allows MM's buttocks to scrape the crepe of her dress. Staring upward, riveted by the sight of Marilyn's sex, the fan operator numbly declares that he has "just seen the face of God." The making of this image, the logo of *The Seven Year Itch* (directed by Billy Wilder in 1955), attracts a restless crowd whose noisy ruckus wafts up the canyon of 57th Street and hovers around a window that frames the figure of Einstein (Michael Emil). It's not long before "the face

of God" meets up with "Einstein's brain," and together they make for a rigidly cuddly duo, acting out their expected mythologies with the finesse of angels with dirty faces. Roeg unplugs the halo that crowns the heroic and suggests that these twin shrines of body and brain suffer not only the strains of objectification but also the demands of the academies (of art and of science) that impatiently await their production. Marilyn is a math whiz held hostage by her body in a culture that prefers her southern lips to her northern ones and demands only her silence, while Einstein's brain has become the ultimate in fetishized machinery. It is the '50s, and the itch that America has been scratching in public for at least seven years helps to alleviate that which it fears most: the Commie boogeyman. Einstein's dread of atomic annihilation, combined with his feelings of guilt and hopes for peace, has aroused the government's suspicions. A senator (Tony Curtis), a political hack from the House Committee on Un-American Activities, relentlessly stalks him, subpoenas him, and tries to shake him down for "a yes, a denouncement, and a few names." Explaining to an incredulous Einstein that "Dachau is the same as what we're talking about now," his tactics abound with intimidation and simple thuggery. Although this is supposed to be 1954, he seems, unfortunately, very much a man of the '80s. Marilyn's husband, a quasi-DiMaggio jock (Gary Busey), swerves from brute to sensitive slugger and serves to further delineate her sexuality and to emphasize the tribulations of the public family.

Although The Blonde and The Brain dominate its decor, *Insignificance* is truly a one-room, four-character movie. At its best, the room buckles with wit, a kind of woozily critical brand

of monkeyshine that shocks you with its sharpness. "You honestly believe I understand rel-a-tiv-i-ty," sighs Marilyn breathlessly as she then proceeds to indulge in a dazzling explanation of the famous theory: a motley crew of objects ranging from *Jane Eyre,* balloons, toy trains, flashlights, to *The Brothers Karamazov* wrangle with each other to produce a narrative of wacky clarity and stunning visual counterpoint. At the film's conclusion, Marilyn basks in self-satisfaction as an astonished Einstein congratulates her. This scene segues to a shot of Marilyn as a child in an orphanage, slowly raising her clothes to reveal her sex to a group of awed young boys. This analogic cutting marks most of Roeg's films, in which bad words detonate firestorms, pleasure prefaces starry night skies, and wealth introduces rivers of liquid gold.

Aside from its visual style, the film is emboldened by its script. Written by Terry Johnson, *Insignificance* was originally a London stage production—which should come as no surprise. Hollywood's inability to encourage or tolerate film projects that display any literary acuity has forced many directors to take their cues from the theater. The adapted screenplay supplies the film's candor and articulateness and illustrates the power of its ideas: that a room in the Roosevelt Hotel in 1954 can serve as a microcosm of current events and popular mythology; that it is possible for a film to address the very repression that has helped twist Hollywood into the pretzel of corporate control and compliance, which it too frequently is today; and that power, sexuality, and money can rub together to produce a firestorm of atomic proportions. When the red-baiting senator tries to confiscate a pile of precious equations, Einstein outwits him by

throwing them out the window. So it rains relativity on the hot-dog stand below and produces an insignificant spectacle of spectacular significance: a special effect that would probably make Marilyn and Albert feel just fine.

1985

The Nightmare Woman
Lothar Lambert

The Nightmare Woman is the purported story of Ulrike S., an actress plagued since childhood by a disfiguring squint. To rectify her figure, Beate M., as the actress is named in this film, undergoes four operations which she hopes will alleviate her imperfection and remove her from the churning vat of misery and despair which she finds herself splashing around in. But nothing helps. Her ex-husband was a grizzly animal who pawed her with the insistence of a neurotic dog. Her current "lover" watches television. Her younger son treats her with contempt, and his brother lavishes her with an empathy rife with sexual confusion. Her psychiatrist dreads her visits. Her mother declines. Her father has taken up with a younger woman. As a result, Beate hallucinates a life of unrelenting glamorous expenditure. She also masturbates a lot.

This film might have been an interesting attempt at dealing with the issue of sexual representation: a depiction of female bifurcation spanning the droll distance between shimmering statuette and weary hausfrau. While recognizing masochism as the preponderant characteristic of most filmic female portraiture, *Nightmare Woman* could have suggested strategies toward the rejection of this comfortable and customary victimization. It could also have made reference to the broad designation of women as objects within the field of men's desires (and non-desires), wrestling with the possibilities of subjecthood for both Beate and the women who are watching her (in the audience).

But rather than consider the gender confusion and despair in this woman's life, we watch an endless procession of ridiculously "divine" episodes attesting to her "fabulously" melodramatic debasement. Though pictured sympathetically, she is soon submerged by a kind of mannered facetiousness, narrowing the movie's code to a sometimes comedic shorthanding of the unpleasantness of being a girl.

Nightmare Woman is a film that speaks of and shows a man's nightmare of a woman. The man, the director, is Lothar Lambert. The woman, the nightmare, is a confused, gaping maw reduced to the essentials of her sexual longing. She is never satisfied. Her dissatisfaction brings us back to Freud's beleaguered query: "What do women want?" The nightmare woman's wants are dictated by her director. Obsessed with the necessity to become his vision of her perfection, she becomes at the same time what he names her: a constancy of imperfection and lack. And all the operations in the world will not disallow her this.

And neither will the film. Like much current German film production, most notably Rainer Werner Fassbinder's, *Nightmare Woman* acknowledges the tyrannies of sexual stereotyping and exercises a sometimes amusing parody of the systems that instruct our desires. But where Fassbinder (especially in such films as *Fox and His Friends, Satan's Brew,* and *The Year of Thirteen Moons,* all of which feature male "heros") works to unleash comedy as a device benevolent in its criticalness, Lambert seems to revel in a brand of humoresque, locating his nightmare woman in a swarmy marsh of nostalgic melodramatic posings and sad grotesqueries. Beate is denied alliances with

other women, who are seen as projections of her own self-contempt. Her vanity stalks her like a mad mirror. And in the film's finale this vanity is posited as the very thing that will save her (for him, the director, who constructs her narrative).

Poorly shot in stylishly inept 16mm black and white, the film's slow, languorous pace creeps to a rousing close. Having joined a rock group, Beate reticently takes the stage and, after a false start, launches into a gyrating rendition of the kind of heart-rending ballad that accompanies much of the film: "This is me. This is my life." During this song we see her transformed into the powerfully staged figure which can contain her narcissism. The accelerated editing alternates facial closeups with narrative flashbacks, leaving the slow particularities of life and rushing into a seductively economic encapsulation. Using strategies of display similar to those of TV advertising footage, this ending offers the viewer a sleek synopsis, a kind of characterological tourism; the constant return to Beate's face is like the commercial's return to its logo, and this face, this logo, dominates this short passage of virtuoso filmmaking. Perhaps the last scene brought out the best in the director because he understood that the resuscitation of the logo (in this case the female of his perfection, the woman named nightmare) is the guarantor of his pleasure.

1982

Dead People
Jews
Roger Deutsch

Before the widespread use of photography, painting (and, to a lesser extent, drawing and sculpture) was the means by which people recorded their appearance for both "now" and later. These documentations swelled the ranks of the portraiture genre and coupled the vanity of the present with a necrophilic regard for the future. Gloating in their jewels and fine tailoring, the dead stare out at us, highlights bouncing off the tips of their noses, peach light caressing their plump cheeks. But deterring us from our fascination with their subsequent rot and disappearance are the institutionalized esthetic strategies of painting and the formal rigor it imposes on its subjects. Morbid curiosity is submerged in the formal accomplishments of the painting itself—by the prowess of the forearm.

But with photography, all this has changed. This is not to say that photographic activity isn't contained by its own visual virtuosities and stylistic precedents but merely to suggest that the replicative skills of the newer technologies of film and video seduce us into a realm of simulation in which the processes of construction are not foregrounded—where labor seems to dematerialize in the "face" of the material. Freed from the need to focus on craft, we abandon ourselves to "reality," to lives and deaths, and to memory and its legitimation as history.

All this comes to mind when viewing the recent films of Roger Deutsch, works that hover over the issues of memory and disappearance and that cannily keep nostalgia at a distance

while seeming to be drowning in it. In *Dead People* (completed in 1984, this was its first public screening), Deutsch tells a fictionalized history of "Frank," an elderly black man whom he actually befriended. But since the notion of friendship suggests a certain reciprocity, perhaps it would be more accurate to call Frank an object of fascination, a "found object" upon which Deutsch could project his own stereotypes. Deutsch tells us that Frank's favorite drink was Four Roses, his favorite food Spam, and his favorite TV show "To Tell the Truth"; that he liked to tell stories about "dead people and crazy people"; that he called his own life's story "My Obituary." Voice-over (Deutsch): "To me it was charming. . . . He invented puns and tongue twisters and I invented him. . . . I'll give him dignity. . . . I'll make a film about him. . . . Then I left town and never finished the film."

This kind of self-betraying candor is all over *Dead People,* and it functions not as apologetic bluster but as incisive self-critique. Deutsch's adoration of "otherness" and its relegation to the position of temporary fancy expose not only the "subtler" varieties of racism but also show how time altered his original perspective on this project. (The footage was gathered many years before the film's completion.) *Dead People* is marked by memorable moments filtered through a kind of foggy chiaroscuro. Shots of rambling highways, desolate main streets, and a "dead" Frank being shaved for his funeral encircle the film with a black-and-whiteness that functions both literally and metaphorically. It is a melancholy exposition of race, life, and death in economically depressed small-town America.

In *Jews,* 1984, Deutsch again engages the "found object" as he strings together a collection of old home movies (which he did not shoot) that tell the episodic story of a well-to-do Jewish-American family between the mid '20s and the mid '40s. Relatives frolic in summer camps, on cruises, and at various celebrations. Children do cartwheels and babies reach peskily for their daddies' necks. Sporting titles like "Allan's First Picture, 1929," "Eagle River, 1931," and "Marcia's 16th Birthday," these moving snapshots rove between black-and-white and color, recalling not only family and world histories but also the history of film technology. The first color sequence in the film appears in 1932, and with it comes the shock of alteration, of a change from the binary structure of black-and-white to the purported verisimilitudes of color and its attendant simulative capabilities.

Another issue these compelling home movies bring to mind is the degree of objectification that constitutes any representation. How does Hollywood-style objectification differ from that of the home movie? And if there is a difference, does it pivot around the familiar points of use and exchange—around the representation's use as an archival record circulated within the family, as opposed to the commodification and exchange of commercial movies? Within the frame of world history, we are forced to consider how the fates of these smiling people would have been altered had their lives been lived out in the Germany of 1939 rather than in the safe confines of the Chicago suburbs.

Deutsch's illuminating picturings push close to film's ability to reactivate the feel of that which has disappeared; but

rather than lolling in the shelter of the simulative, both of these films subtly question their characters' relation to history and to their own deaths. They are portraits that remind us that these characters are done, through with, no more; yet at the same time, they bring them "to life." They question cinema's ability to formalize, to resuscitate, and to re-represent the past.

1986

The Draughtsman's Contract
Peter Greenaway

After taking out the eyes and ripping off the shirt of a picaresque artistic hero, a band of aristocratic gentlemen proceed to murder him while haughtily asking the question, "What is a man without foresight and property?" The answer, aptly illustrated by their victim's swift demise, is, of course, "nothing." This final scene from Peter Greenaway's *The Draughtsman's Contract* suggests one reading of the film's meanderingly intelligent and erratically economic narrative, which cleverly entertains a suite of themes ranging from the primacy of property and power, to the encapsulation of the libidinal within the monetary (and vice versa), to how artistic practice is prescribed by formal conventions and proprietary extravagance.

Set in the English countryside of the late 17th century, the film depicts the arrival of a draftsman, Mr. Neville (Anthony Higgins), on the Herbert estate. Here, in the absence of Mr. Herbert, he is recruited to execute 12 drawings of the property. In exchange for this task he will receive a modest fee, which is then supplemented by Mrs. Herbert (Janet Suzman), who offers him her body. This generosity is later mimicked by her daughter, Mrs. Talmann (Anne Louise Lambert). A contract is drawn up and the renderings begin. But as the assignment proceeds, a certain dissembling aspect begins to invade the drawings: objects appear that don't belong, and strange clues suggest oncoming rude awakenings that finally result in the discovery of Mr. Herbert's body. So *The Draughtsman's Contract* is a tale of murder

which slithers into a yarn of adultery, struts into an outline of patrilineage, flourishes into a scrutiny of artistic patronage, drifts into a consideration of allegory, and tumbles back into a tale of murder.

But while constantly threatening to do so, the film just misses dissolving into merely a suave salute to the good life, an uncritically adoring puff of historicism. Rather, it casts a satiric eye on convention and its invasion of the social life of the period, from the delicacy of a curtsy to the binding rigor of a contract. This is not only conveyed through the use of tableaux and anecdotal hesitations, but also voiced in an insistently intelligent and witty dialogue. The narrative advances through a series of structural demarcations, a procedure present in many of Greenaway's prior films; these stanzas begin with a long shot of the area of the estate to be sketched, proceed to the actual drawing, and broaden into tightly orchestrated bundles of incidents, retorts, and positionings. Combining a virtuoso display of language with an amusingly lascivious sexuality (a forbiddingly formidable coupling), the film reminds us of the ability of capital to define who is ravished, and when and where. *The Draughtsman's Contract* is embroiled in the narrative relationships of seemingly unrelated incidents and ingeniously details the conspiracy of inheritance. Esthetically, the film is a smashingly attractive conceit about the smashing attractiveness of esthetic conceit.

So one might wonder how a film as thoughtfully wrought as this has managed to become a popular item both on the festival circuit and in commercial venues. In America *The Draughtsman's Contract* emerged at an opportune moment—that

of the cresting of a kind of filmic Anglophilia which threatens to submerge the colonies like a tidal wave of tea and crumpets (*Gandhi, Brideshead Revisited, Chariots of Fire,* etc.). Another enhancement is Greenaway's ability to cloak his criticality in a costume of seductively palatable mastery which has proven irresistible to the culture vultures. And this exotic foreign morsel has slightly post-graduate PBS leanings—there is a pronounced self-congratulatory lilt to the entire proceedings which constantly foregrounds the director's cerebral prowess while also seeming to flatter the spectator who has the "good taste" (and class?) to appreciate the refinements at hand.

Nevertheless, *The Draughtsman's Contract* reminds us why intelligent cinema remains such an astonishment: we almost never see it. Without the support of the British Film Institute and Channel Four this film and many other independent British works could never have been made. One can only hope for equally ambitious funding procedures and distributive capabilities on this side of the pond.

1983

Casual Shopper
Judith Barry

Call It Sleep
Isaac Cronin and Terrel Seltzer

Casual Shopper by Judith Barry and *Call It Sleep* by Isaac Cronin and Terrel Seltzer comprised a program of video tucked under the title *Ideology and Praxis*. Both works examine the mechanics of looking and how it inhabits and surrounds the ideological— *Casual Shopper* focusing on desire, consumption, and the architectural directive, and *Call It Sleep* on the preponderance of the "spectacle."

As Walter Benjamin stated, "If the soul of the commodity . . . existed, it would be the most emphatic ever encountered in the realm of souls, for it would have to see in everyone the buyer in whose hand and house it wants to nestle." Apropos of this charming anthropomorphic exercise is the tune that intermittently accompanies the unraveling of *Casual Shopper,* a lilting Muzak rendition of "Call Me" in which the beckoning but patient commodity can be heard crooning "Call me. Don't be afraid to just call me. . . . Call me and I'll be around." Around everywhere, from the baroque shopping palaces of the late 19th century to the contemporary suburban merchandise behemoths. The pedestrian traffic within these structures resembles a carefully punctuated and at times graceful dance of acquisition performed against a familiar backdrop: the seamless exposition of the market economy. It is a critique of the pervasiveness of "goods," along with immersions of romantic melodrama and narcissism, that are the stuff of *Casual Shopper.*

"Call Me" segues into "Let's Do It, Let's Fall in Love," as we watch a woman stroll somnambulistically through a shopping mall—a meandering corridor of towel racks, negligees, and bric-a-brac. Offhandedly fondling any piece of merchandise within arm's length, the woman pauses only to react to the inquiries of hopeful salespeople. "Can I help you?" "No, I'm just looking," she replies. The constancy of this scopic exercise, this "just looking," connects shopping to the cinema (and television), where, Barry has noted, we go to see, to experience over and over, our own desire.

So the narcissistic shopper lurches on, her four-inch heels and clutch bag guaranteeing the necessary amount of bondage and physical disability while she continues her procedure of visually framing the products that comprise her image of perfection. Then, across a crowded room, is sighted the amalgam of difference: the man. Floating up escalators and slipping into various coats and hats, he too is shopping. They meet at the magazine rack. He disappears. They meet again in the stationery department. They kiss. She fondles his lapel as if the jacket were still hanging on the rack. Now she is leafing through a fashion magazine and commenting on the models. "I think I have one of these faces. Like a decoy." This moment of speech (of which there are few) adds a curious element of interest. Does one consider the female face as the locus of fakery and enticement? The headquarters of the simulacrum? Or does one consider the fact that the actress' face is not "like" that of the fashion models in the magazine, but a desperate simulation—a decoy to the third degree? Is the inadequacy of the copy purposeful? Is the

clumsiness of the camera work a rude reminder of the possible gracelessness of the usually infallible exposition of the TV commercial? Is the refusal to duplicate the elegant maneuvers of the commercial a strategy of the work—an intervention in the "naturalness" of the advertising overture?

In an essay by the artist, "Casual Imagination" (in *Discourse,* no. 4, Winter 1981–82), and in small segments of *Casual Shopper,* one appreciates the rigor of Barry's analysis of the activation of the pedestrian's desire and of how commercial space is mediated by the television commercial. *Casual Shopper* resists the critical considerations of the essay, but on an interesting level, its promises and non-delivery produce a similar procedure of lack and desire as does the universe of commodities that it purports to scrutinize. One hopes that Barry will continue to consider this uneasy confluence: her skewed reenactment of offering and denial might suggest some possible detours around the constancy of the spectacle.

This dominance of the spectacle, this panorama of social relations mediated by images, is examined in *Call It Sleep.* The tape is touted by its makers as being "the first visual work produced in the U.S. which makes use of the situationist technique of détournement—the devaluation and reuse of present and past cultural production to form a superior theoretical and practical unity." It is impossible to ignore the ludicrous pomposity of this declaration, and of the many others sprinkled like stink bombs throughout what is otherwise a formidable compendium of analytic prowess and relentless jargon. This "superior theoretical and practical unity" is divided into four parts: "The Spectacle," "Bolshevism," "The Cadre," and "The New

Revolt." Through the use of appropriated footage, text, voice-over, and scripted scenes, it recapitulates Guy DeBord's situationist manifesto *The Society of the Spectacle,* and illustrates his assertion that the spectacle degrades being into having and slides having into appearing.

Defining the spectacle as that which exists everywhere and at all times, part one conflates footage from Hollywood movies (*Close Encounters of the Third Kind, Apocalypse Now,* etc.), TV commercials, and a snippet of TV's *Fame* dancers into a kaleidoscope of social directives: the image as the organ of class domination. This is followed by part two, a critique of Bolshevism's effectiveness as a means of opposition to the spectacle, adding that the flaw in terrorist activity is in its mistaking the desperation of the lone adventurer for the desperation of the proletariat. Part three depicts the "cadre," who is named as the reformer of daily life; at times this may be the leftist intellectual who, supported by the bourgeoisie, indulges in rigorous intellectual exercises without consequence—the vanguard troubleshooter, the muckraker of the atelier, the critic as scientist, the connoisseur of fine wine and pâté. We are looking at what is, perhaps, a sunny day in the Berkeley hills, watching well-appointed characters loll in swimming pools, laboriously burrowing into the crevices of bourgeois psychologizing (or exploring the butterflies of their minds). Part four, "The New Revolt," juxtaposes documentary footage of South African street skirmishes, Paris in 1968, and a scene from the film version of Bertolt Brecht's *Galileo.* Championing the Soweto rebellion of 1976, Cronin and Seltzer praise the rebels for "setting no goals for themselves other than their total emancipation." We are told

that no one is excluded from the possibilities of the new revolt. In the final shot we see an image of the cadre couple watching TV, over which is superimposed "All these ideas are in everyone's head."

DeBord has stated that "in the spectacular one part of the world represents itself to the world and is superior to it." Although *Call It Sleep* aligns itself with the notion of opposition to the spectacle, it engages in a ridiculously patronizing address, mired in its "superiority as a theoretical and practical unity." It *is* a detailed accounting of the spectacle as the self-portrait of power, and of the poverty of social relations. Unfortunately, this accounting is broadcast via the conventional bastion of address, the male voice-over, a droning non-stop spouting of the proper rendition, simmering in its correctness. (Yes, professor, nods the smiling co-ed in the sixth row. She, like the spectator, is absent, playing nature to his culture.) Another tyranny of appearances without reply. These ideas are in everyone's head. The spectacle is the guardian of sleep. Wake up, professor, it's time to clean the pool.

1983

Kids Я Us or Viva Poland or Laudable Odds and Ends
New York Film Festival

When one film follows another in quick succession, when a chorus emerges from a collection of seemingly disparate voices, you start to make connections, linking together comfortable segues and queasy commonalities. You become not the spectator of a single film but the audience for a cinematic anthology which itself is a work, a particular type of curatorial accomplishment replete with themes and subtexts. After I'd seen about twenty-five films at this season's New York Film Festival, certain thematic confluences began to rise subtly to the surface like a cup of coffee cursed with last week's milk. And milk, the juvenile's beverage of choice, seems an apt garnish for a festival that clearly had its mind on children.

It is not impossible to compare the viewpoint of children with that of adult media spectators, who also see this "shown" world via an alteration of scale; whether through the reduction of video or the enlargement of film on the screen, the spectator is handily transformed into an agreeable, mute child. Corporate Hollywood movies have, in part, constructed this focus, and ceaselessly perpetuate it. In Paul Brickman's *Risky Business* (1983), for example, the point of view is ours as well as the young hero's, whose parents recite a litany of dos and don'ts that he must obey during their absence, directing his use of their suburban semi-Xanadu. It is we (through our suggested identification with the boy hero) who receive, understand, and harmlessly rebel against the maintenance of suburbia. The epics

of Stephen Spielberg repeat the conventional narrative opposition between a phantasmagorical universe of childhood benevolence and an implacably repressive adult domain; it is we, as well as the children, who cry at the lack of a universal language, in *Close Encounters of the Third Kind* (1977), and at the sureness of death, in *E.T. the Extra-Terrestrial* (1982). In an interesting reversal, prime-time television is currently inundated with a spate of sitcoms that feature kids stricken with the traits of adult behavior; they are scheming, manipulative, and oppressive (and in the case of *Family Ties,* right-wing), while the cowering parents are gentle and guileless. Perhaps these devilish juveniles are the work of TV writers who, being veterans of the '60s, are playing the role of avenging angels, etching out acidic portrayals of mean-spirited, calculating tot-reactionaries.

The "kid movies" included in this year's festival are not the products of corporate Hollywood. They are clearly less *for* youth and more *about* it. Jim Jarmusch's *Stranger Than Paradise* (1984), Maurice Pialat's *A Nos Amours* (1983), Márta Mészáros' *Diary for My Children* (1983), Wojciech Marczewski's *Shivers* (1981), and, more peripherally, Jean-Marie Straub and Danièle Huillet's *Class Relations* (1983), Jacques Rivette's *Love on the Ground* (1984), Andrzej Wajda's *A Love in Germany* (1983), and Wim Wenders' *Paris, Texas* (1984), all concern themselves with childhood (or an adulthood granted the dispensations of childhood) and its relationship to the economic and social field that contains it. *Stranger Than Paradise* drags the lineage of the European Art Movie into the Peanut Gallery with cute and amusing aplomb. Near the film's beginning we see a graffiti-strewn wall which wears the line "U.S. out of Everywhere." Jarmusch

seems to have taken this very seriously, as he has managed to make a film about an America in which America is missing. European filmmakers are masters of this kind of geographic subtraction, but Jarmusch is one of the first home-grown practitioners. Peopled by guys who wear faces from a Fassbinder wet dream of a decade ago, *Stranger Than Paradise* is a smartly economic movie which understands its limitations and contains them in an astute, comfy manner. Its episodic structure escapes the demanding resolutions of literal narrative and adds to the film's skit-like surface. To some, it's a "nice" film, a good-natured giggle, a fresh foray into a "new hip American independent cinema."

But *Stranger Than Paradise* is really about cool, in that cool is about gesture—the fold of a collar, the cut of a jacket, the speed of a shuffle. Cool is always seen and almost never heard. It's about body language and seldom about spoken language. And when it is "said" it's usually withholding and parodic. Cool knows its limitations and is cool enough to keep them a sweet secret. Cool understands the mean spirit that flourishes in quarters where exclusion is aped and stylized. Amusingly, those on the outside looking in at cool actually find it all nice and good-natured. They're not considering its investment in contempt. *Stranger Than Paradise* is a quick, funny fairy tale whose low budget shows up all those in "the business" who waste blockbuster bucks tooting away forty grams to write five pages of shit dialogue. If Hollywood turned out more cool films they wouldn't even have to write dialogue.

But back to the lives of the kids in *Stranger Than Paradise*. Willy (John Lurie), Eddie (Richard Edson), and Eva (Eszter

149

Balint) were probably never really kids but in another way they always will be. Eva jets in from Budapest and crashes with her cousin Willy, who lives in a perfect shithole of a place. He watches TV while he downs TV dinners, explaining, "This is the way we eat in America." He instructs Eva not to say she's going to use the vacuum cleaner but that she's going to "choke the alligator." Willy and Eddie are friends. They play cards, loiter around, and do routines. Eva splits to Cleveland to visit her Aunt Lotte (Cecilia Stark). Willy and Eddie joyride out to join her. Everything in this rotten post-industrial landscape looks like hell. Autie's house is butted against a railroad track, as almost every other structure in this film seems to be—making many shots look like swipes from O. Winston Link. Leaving behind the adorable aunt who talks funny, the threesome heads for Florida, where they buy sunglasses so they'll look like real tourists. They survive on scams, petty pilfering, card tricks, and racetracks. They decline the designation of "responsible adult" and shuffle around just fast enough to catch the gravy train before they're flat broke. Lucky things happen to them. It almost seems like they're slumming till the trust fund comes through. They're never inconvenienced by pleasure or desire. (Except for Eddie, whose little quirks tend to de-cliché him. He'd better watch it; Willy might leave him flat for a cooler friend.) They all seem dressed up in someone else's clothing which is just too big for them, as though they raided the attic and found mommy and daddy's old duds. *Stranger Than Paradise* is a disingenuous yet winning parody of everything, which picks up mileage by dressing kids up and dressing America down.

The adolescent sexuality that is hardly even implicit in the Jarmusch film is made stereotypically explicit in *A Nos Amours*. Pialat's film contends with the trials and tribulations of dealing with a young girl's exploding desire; of trying to tame the pulsating, undulating irresponsibilities and insatiable needs of a budding yet already voracious gaping maw. In other words, *A Nos Amours* is the latest Franco-nympho export film. This is the kind of movie that funnels so smoothly into the Paris Theatre/Lincoln Plaza art-house circuit. Using his mastery of conventional narrative exposition, Pialat indulges his notion of unwieldy female sexuality but is savvy enough to envelop his saga in the wraps of "domestic melodrama," giving its picturesque T&A the validation of "sociological exploration." Suzanne (Sandrine Bonnaire) strikes terror into the heart of her family, detonating raucous screaming sessions, but still finds time to break young boys' hearts. She seductively purrs, "For the while it's you. You're cute," and seduces them with fantastic promises—"I'll make you 15 again." She proudly declares her allegiance: "I'm on no one's side. I'm for myself." And what a demonic young beastie she is. With Pialat (of course) playing daddy, the man she *really* desires, Suzanne emerges as just another churlish dragonette, another directorial wet dream presided over by papa.

The father/daughter theme as a subtext extends to Mészáros' *Diary for My Children,* a semi-autobiographical view of the oppressive Stalinization of Eastern Europe. The film can be seen as a complex examination of the relationship between Juli (Zsuzsa Czinkóczi) and her guardian, Magda (Anna

Polony), a staunch party functionary who supposedly exemplifies the repressive force of the regime of Matyás Rákosi. But it also can be seen as a strict delineation of character, eschewing subtlety and difference, and thereby replicating the binary extremities of the regime it seeks to criticize. It is the Hungary of 1947, and Juli is an orphaned teenager returning from Russia; her mother is dead and her sculptor father has disappeared in the Stalinist horror, dragged from his studio by the secret police. Magda adopts her, but Juli is lost in reveries of her parents' idyllic love, which we see as a slow-motion, utopian familial romp through some Uralian Shangri-la. These fantasy passages, combined with the escapism of her constant moviegoing, constitute the bulk of Juli's concerns, pulling her away from her role as dutiful youth to that of moping truant. Repulsed by Magda's attempts at concern she cathects to János, a colleague of Magda's and not incidentally played by the same actor (Jan Nowicki) who embodies Juli's fantasy of her father. She compounds the authorities' suspicion of János by moving in with him and his son. But Magda and the regime she represents continue to stalk Juli. The fact that her connection with János seals his fate and guarantees his arrest is of little concern to her. The tangible presence and vulnerability of those who people her world mean little to her. She communes only with a phantasmagorical yesteryear or (like the child/spectator she is) with huge figures on a movie screen that emphasize her own miniaturization. Magda's character escapes momentarily from the clichéd portrayal of Commie ogre, but Juli seems forever sealed as a sullen scamp. Parading around like "her majesty the baby," she appears less a victim of the regime's (and Mészáros') over-

determined melodrama and more like some little princess who gets sulky on the maid's day off. While Mészáros intends to picture Juli as a brave little freedom fighter bucking the tides of oppression with an assertion of her own desires, the character appears merely as a narcissistic projection emerging through the autobiographical mode. Unfortunately Mészáros does not speculate on what might exist outside the dualities of oppressive totalitarianism and anesthetized self-interest.

Marczewski's *Shivers* handles similar terrain, focusing on the Poland of the mid-50's. Tomek (Tomasz Hudziec) is a young boy caught in the powerful push and tug between Church and State, between the admonishments of Catholicism and the dictations of the Stalinist left. The climate is rife with canaries who sing to the authorities and fathers (like Tomek's) who disappear in the night. Tomek is sent to a Communist youth academy, where he crawls through a miasma of physical and psychological trials. The academy is a buzzing nest of zealous adherents, religious malcontents, and a young woman instructor who, like Magda in *Diary for My Children,* is condemned to play the role of "repressed femme ideologue." *Shivers* excels at its depiction of the complexities of childhood, its unmasked little terrorisms and stirring sexualities. But what begins as a densely rich portrait of adolescence under duress soon thins out into a silly cartoon of duplicity and corruption, marching on to a ridiculous narrative closure. In a relentless process of social alignment Tomek, who up until now has been a model of juvenile indecision and relative benevolence, stares at himself in the mirror, wets down his hair like an ardent comrade, betrays his friends and family, and begins spouting the

jargon of the regime with the precision of a seasoned ideologue. Was his toothpaste spiked with LSD? Was the moon full? The film's final 15 minutes are so abruptly silly that they struggle the entire project to the ground with the ease of Hulk Hogan flooring *Riptide*'s Murray Bozinsky.

Aside from the festival's focus on children, another theme can be noted: the picturing of Eastern Europe under the thumb of Stalin. In addition to *Diary for My Children* and *Shivers,* attention to this period surfaces in a number of other films as a kind of casually dropped mention, a shorthand signal of "human interest" and "concern." Victor Nuñez's *A Flash of Green* (1984) tells of the battle between ecologically minded community folk and land speculators in West Florida. One of the characters is a maverick scientist, a woman who was apparently banished from her profession many years before because she had translated the work of a Hungarian colleague. Although the film is more than vague about the circumstances surrounding the incident, I suppose one is meant to surmise that she was victimized by McCarthyism for aiding a victim of Stalinism. Wajda's *A Love of Germany* takes place during World War II and tells of a young Polish prisoner of war condemned to death by the Nazis for the crime of being the lover of a German woman. The authorities offer him the privilege of being "aryanized," to become German, which he vehemently declines, preferring death to the erasure of his Polishness. And even in *Stranger Than Paradise* Eva is a visitor from another planet called Budapest.

What becomes interesting is how these films are read in a festival such as this one, in the America of the mid '80s. This

has always been a country that has sported a cavalierly undif-
ferentiated reading of the political left, equating government-
subsidized health care with the boogey man of "socialized
medicine," union organizers with "commie dupes," and anti-war
demonstrators as "outside agitators." It follows from this that the
explicit and much-needed critique of Stalinist Moscow in these
films will, in America, inevitably collapse into a generalized
attack on any political activity on the left. While it is important
to criticize the evacuation of freedom in Eastern Europe, it is
equally important to keep in mind the American government's
soft spot for authoritarianism on the right. These films, which
seemingly deal with the anthematic struggle for liberty, wind up
like sentimental cartoons of victimization. Ultimately uncritical
of how institutions and belief systems (churches, corporations,
governments, and families) really *do* dictate power relations,
they swell into broad-based collections of "feelings." But greet-
ing cards rarely save lives. These films are sloppy salutes to the
purposely general idea of "human universality": a flowing of the
milk of human kindness that miraculously heals the wounds of
everyone everywhere (because everyone is the same) and warms
the hearts of numbed-out filmgoers and festival directors. They
are symptomatic not only of this festival but of contemporary
culture in general: of a non-specificity which blurs the impor-
tant distinctions between left and right, between then and now.
They solidify corporate power, reduce memory to the dictations
of the thirty-second spot, and eradicate the palpability of history.
So the same Film Festival audience that cheered for *Diary for
My Children* could easily go gaga over *Boat People* (1983), Ann

Hui's entry from last year, which gives *Red Dawn* (1984), John Milius' "me big Yankee hard-on make commie die" singsong, a run for its money.

Finally, mention should be made of three laudable loose ends which were perhaps the strongest entries in the festival. Nelson Pereira dos Santos' *Memoirs of Prison* (1984) connects with the Eastern European films in that it examines the tortuous disappearance of human rights, but this time the oppressor is Brazil's right-wing regime of the 1940s, which imprisoned thousands of left dissidents. Adapted from a semi-autobiographical novel by Graciliano Ramos (which was written during his own incarceration), it not only chronicles the hierarchical ordering of the Brazilian penal system but also considers how experience is organized through art-making. Unlike the films of Mészáros and Marczewski it does not present a binary universe of absolute right and absolute wrong, but instead studies the degrees of intolerance, the comedic ironies and shades of contradiction, that comprise relations of power.

Intolerance and irony's sad reckonings are also the stuff of *The Times of Harvey Milk* (1984), Robert Epstein's powerful documentary which chronicles the 1978 double assassination of George Moscone, San Francisco's mayor, and Harvey Milk, the openly gay politician elected to the city's Board of Supervisors. Gathering together TV news footage and talking-head interviews, Epstein shows both the liberating force of Milk's presence in San Francisco's politics and the repressive backlash which ensued, culminating in the murderous rampage by fellow Board member Dan White. That White today is a free man attests not only to the farcical antics of the justice system, but

also to America's affection for the violence that simmers just below its surface. *The Times of Harvey Milk* is an effective and eloquent comment on this tragic state of affairs.

American-style violence, replete with Texas bars, rock'n'roll, radio preachers, and corny jokes, is the stuff of *Blood Simple* (1983), Joel and Ethan Coen's crazily confident first feature, a rowdy homage to noir and gore. A bad marriage results in extracurricular sex, which makes for a divorce detective, which leads to trick photography, which detonates murder, which culminates in an orgy of foul-ups, bleeps, and blunders. Dan Hedaya, M. Emmet Walsh, Frances McDormand, and John Getz head up an impressive cast which acts out the zany intricacies of the Coens' script with a kind of deadpan hysteria. But this possible contradiction enlivens the movie, making it not only a good-ol'-boy romp but also a chillingly effective comment on the machinations which underpin the love affair with violence. Whether construed as foreplay, diplomacy, or the trickery of a redneck detective, machinations of this sort often make for the caper-like quality of American life and give the film the sourly ringing feel of truth. Dogs saunter through corridors, cigarettes dangle languorously from the mouths of stuffed animals, and guys clean up bloodbaths to the accompaniment of the Four Tops crooning "It's the Same Old Song," making the entire scene look like some radically disheveled Mr. Clean commercial. The rejected husband tries to explain his psychological condition to his philandering wife by pointing to his head and bleating, "In here I'm anal." This kind of wacky shorthanding marks most of the dialogue and accounts for the Coens' ability to juggle drawling Texas vernaculars with terse

one-line jabs. But perhaps the film's most effective component is Barry Sonnenfeld's stunningly eccentric cinematography, which clumps together a gang of skewed viewings into a crazy quilt fit to adorn any asylum. If one recalls that Dan White, Harvey Milk's killer, was able to cop a plea for manslaughter on the grounds that he ate too much junk food, then *Blood Simple* seems horrifyingly on the mark. Hey kids, stay away from the Twinkies.

1985

Superstar:
The Karen Carpenter Story
Todd Haynes

Lost in space somewhere between "Close to You" and "Long ago and oh so far away," Karen Carpenter's voice throbs with romantic duress in a trilling vocal package. Along with her brother, Richard, she constituted the Carpenters, whose excruciatingly clean-cut musical embroideries provided a score for the early '70s. That time teetered on the cusp of political rebellion but still wanted out from the rowdy negativities of the preceding decade, and looked vehemently to a phantasm of values and histories that never existed—a phantasm that was, in part, choreographed by America's first and last demi-holographic president, Richard Nixon.

That Karen Carpenter's voice issued at a time that was also an era of renewal for various feminisms is a sad irony, which foregrounds the discrepancies that mark women's struggle for both equity in the work place and some degree of control over their bodies. For it was a distortion of this quest for bodily control that drove Karen Carpenter to her death, at the age of 32, a victim of anorexia nervosa, an affliction whose sufferers become obsessed with their weight and the amount of space they take up in the world. Starving themselves into a deadly image of their own (im)perfections, they favor a cultural ideal over physical existence. Finding themselves in an impossible position, these mostly white, middle- and upper-class women may experience the disease as a strategy for independence but

end up, instead, robbing their bodies of flesh, juice, and voli-
tion, literally disappearing into thin air.

This disappearing act is the subject and object of *Superstar:
The Karen Carpenter Story,* 1987, a film by Todd Haynes. The
film defines anorexia nervosa as an "abuse of self-control, a
fascism over the body" that are a response to "a culture that
continues to control women through the commodification of
their bodies." To capture the palpability of this corporal ab-
sence, Haynes uses dolls to tell the tale of Karen's rise, fall, and
evaporation. This device, although familiar, works. It recalls the
use of dolls to perpetuate stereotypes, their function as our
surrogates in childhood's first narrative constructions, and it
literalizes the corporal reductivism and miniaturization of diet-
ing. This doll's-eye view is then conflated with footage of
military maneuvers in Vietnam, vintage Nixonian portraiture,
demonstrations, beauty pageants, SoCal highways and tract
houses, and a forthright analytic text written by Haynes and
Cynthia Schneider, which the viewer both reads and hears in
voice-over.

Foregrounding the disease as a symptom, in part, of repres-
sive familial control, the film opens with the sounds and sights
of Karen's mother's discovery of her daughter's body in the
family home. Shot in a tension-laden, cinema-verité-ish style,
the camera shows us mommy's point of view but not mommy,
as she stalks the premises, searching for Karen. Up and down
foyers, through the living room and bedroom, the topsy-turvy
camera bobs manically until it bumps into the body. All this is
accompanied by a throbbing musical crescendo which makes

for a tackily effective, melodramatic denouement. These initial scenes carry the labels "A Dramatization" and "A Simulation," comedically suggesting that the doll-u-drama that follows could possibly be mistaken as an exercise in verisimilitude. In fact, it is this joining of parody with deathly, bodily abjection that makes for the film's tension, allowing it to engage both social critique and the cathartic dispensations and distancing of laughter. We are taken on a Barbie-and-Ken-athon that marches from family dinners to meetings with record industry weasels to a cruise down the freeway as Karen's static polyurethane head gazes lovingly at the plastic Richard propped up at the wheel. A live-action music critic, a DJ, and a vocalist supply ironically delivered expertise on the Carpenters' melodic prowess. A voice-over gives us a short lesson on American food consumption and display and how they were altered after World War II. All this and more are encased and veneered by the Carpenters' music, a brayingly saccharine (what else?) tumult of "I fell in love with you"s.

But perhaps it is not this music that serves as the logo of the film. Shots of spankings, broken glass, toilet bowls, and piles of food melt into one another and repeatedly coalesce into a simple but glowing red, white, and blue graphic image of an object. No, it is not the American flag around which the film's narrativity congregates, but a logo of a different order—a product that, like the nation's emblematic banner, has the ability to delineate the looks, sounds, and purges of young women like Karen Carpenter: a luminously omnipresent box of Ex-Lax. It is perhaps this "small" film's triumph that it can so economically

sketch, with both laughter and chilling acuity, the conflation of patriotism, familial control, and bodily self-revulsion that drove Karen Carpenter and so many like her to strive for perfection and end up simply doing away with themselves.

1987

Difference: On Representation and Sexuality

The films included in the "Difference: On Representation and Sexuality" exhibition are clearly not the same as those produced by corporate Hollywood. Selected by Jane Weinstock, there are no stories of adorable boy hoodlums overtaking entire high schools, no renegade cops undermining police bureaucracies by virtue of their sheer wit and cuteness, and no square-jawed private eyes navigating through a miasma of calculating jiggle. Rather than showing sexuality in an immutable, natural state, the films suggest a socially constructed sexuality, a perpetual shifting of positions, voices, and bodies only biologically fixed to gender. This collapsing of a binary notion of sexuality into a series of locations, pleasures, and repetitions is accomplished through a variety of cinematic procedures, ways to show and tell which escape conventional narrative closures and singular "character development." Stories are punctured and rewritten, histories are undermined, humor is deployed, conjugations are conjured, and pronouns are paraded promiscuously.

In *Thriller,* 1979, Sally Potter rereads and rewrites Puccini's *La Bohème* (1896). Opera seemed to Potter an apt form for scrutiny since she sees it as "a particularly clear example of the role of fiction in the production of ideology." To call *Thriller* a rereading might imply attention only to a text and its subsequent skewing via other texts, but a film is not a book, and *Thriller*'s complexity results from the joining of its textual activity to a string of fluently pleasing images, a collection of black

and white "still lives" which splinter the scene of the "original" spectacle and substitute its melodic lyricism with a series of questions, quotes, and laughters.

A voice-over by Mimi (Colette Laffont) examines the possible difference between her own labor as a seamstress, the work of the prostitute Musetta, and the creativity of the young men in the opera: a poet, a painter, a musician, and a philosopher. Is all poverty the same? "Do they suffer to create as I must suffer to produce?" "Could I have been the subject of the scenario rather than its object?" "Could I have been the bad girl, the one that didn't die?" In *La Bohème* Mimi's identity is fixed in a single body, but *Thriller*'s Mimi is all over the place. She investigates her own murder, becomes a "bad girl," and reads books on theory and laughs at them. Potter's scrutiny of *La Bohème* casts aspersions not only on opera as a cultural offering but also on the class and subject/object relations at work in a unified narrative, on the humorlessly rote repetition and mimicry of some theoretical pronouncements, and on the picaresque adventures in poverty that envelop much artistic production.

In *Committed,* 1984, Sheila McLaughlin and Lynne Tillman engage in the rewriting of a different story: that of the actress Frances Farmer's dive from activity to lobotomy. The medical procedure Farmer underwent is described as one that "severs those nerves which give emotional power to ideas," so the film can be seen as addressing the silencing, the rendering inactive and absent, of a speaking subject. While Hollywood's rendition of Farmer's life is just another "life story," McLaughlin and Tillman work to break down the singular sad song into a chorus of ambient exhortations, rationales, confessionals, and

audience participations. Moments of expository speech dot the film, giving it a sense of histories, differing narratives, and melancholy soliloquies. Frances' mother (Victoria Boothby) warns a radio audience to beware of commie entrapment. She is accompanied by an announcer extolling the virtues of mental hygiene, which has found its "right humus in America." Frances (McLaughlin) languishes in a mental hospital and confesses to a nurse that she is a casualty of love, involved in a relationship where "pleasure and pain are inextricably linked," where you "can't tell feeling good from feeling bad." Clifford Odets (Lee Breuer) zigzags from punishing sadist to sorry little boy; acting out the old "good nipple/bad nipple" routine to the hilt, he degrades Frances and praises his wife as a saint. Farmer and Odets are seen as romantic contortionists in a grim ballet. Their "scenes" are powerful because they are free of the manner and stylistic embellishments that loiter around most narrative depictions of sexual obsession. No magenta light bounces off Frances' forehead, no Armani is strewn sloppily around the room, no sunglasses or raincoats soften the blows. *Committed*'s formidable script takes on American-style red-baiting, psychiatry's mania for alignment and "normality," the complexities of the mother/daughter relationship, the brutal choreography of romance, and the unified expediencies of the biographical mode.

If *Thriller* is about a number of different "shes" and *Committed* fractures the singular historical "she," perhaps Chantal Akerman's *Je, Tu, Il, Elle* (I, you, he, she, 1974) is an outline of the possibilities of the pronoun as the motor of narrative, the shifting focus of the conjugation. Throughout the film Akerman's own figure is a constant, whether embroiled in the nar-

cissism of display, contained by passivity, or activated by passion. But though *Je, Tu, Il, Elle* has the makings of a flaunting confessional, its severe exposition, long shots, and tableau-like presentations lend an anthropological feel to the proceeding, turning even explicit sex scenes into "scenery," into "exhibit A's," into studies in sensations, noises, and bodies. Multiple bodies also inhabit Yvonne Rainer's *Film about a Woman Who . . .*, 1974, to the extent that "who" the "woman who" is becomes questionable. A number of unnamed women take part in a meandering conflation of verbal admissions, conversational and photographic arrangements, and smidgens of moments which suggest a woman's reaction to "her own perfection or deformity." Rainer's work proceeds amidst the acknowledgment that "if the mind is a muscle, then the head is a huntress and the eye is an arrow." If the eye can be an arrow, perhaps the film attests to the possibility of removing women from the line of fire and doing so with smart impertinence and knowing laughter.

These films and many others in the program suggest a different way of storying, of not making a point but straying persuasively. But although *having* a point can be a gender designation, *making* a point can be a sexually instructed activity, and one hopes in the future to see more critical work by men that addresses issues of sexuality and representation. The films I have mentioned, however, are made by women. They should encourage other projects intent on recognizing a female spectator, on welcoming a multiplicity of feminisms. So we hope for the emergence of different kinds of films, whether through the maneuvers of a theoretically derived cinema, from a more

artisanal, artworld context, or even sneaking between the phantasms of Hollywood. The boys may be taking over the high school but the girls' minds are elsewhere. And when they show and tell us about it, it just might be a very different kind of story.

1985

Recoding Blackness:
The Visual Rhetoric of
Black Independent Film

"Recoding Blackness: The Visual Rhetoric of Black Independent Film" was a collection of recent film and video works curated by James Snead. According to Snead, the ideological coding of blackness suggests a condition of submissiveness, lacking, and absence: a continual "otherness" that exists only to substantiate the power and pervasiveness of whiteness. And, of course, it is this very whiteness that constructs and colors the ideological code.

The films and video presented here were divided into three programs, the first of which worked to "clarify the effects that codes have on the self-image and welfare of the black community." In *Death of a Dunbar Girl,* 1974, by Henry Miller, this self-image is flooded with distortion and self-contempt as we witness a daughter's visit to her ailing mother. The initially mannered and repressed social ritual soon transforms into a harrowingly episodic traipse down memory lane. Escalating into a roller coaster ride of vengeful assaults and baiting innuendo, the encounter is eerily punctured by moments of sympathetic calm and tender reminiscence. Accusations cover the ground from sexual improprieties to familial abandonment but all are coated with a thick veneer of color-conscious self-repudiation (on the mother's part), a second skin pocked with desperation and disavowal. This woeful scene is then eloquently encapsulated by the daughter who ventures that "everybody is dead and dying in this cold white world of death and manners." The

proceedings are finally brought to a halt by the mother's increasingly frantic vocal rendition of "Bye Bye Blackbird," belted out by a blackbird who is indeed singing her final bye-byes. The mother's freeze-framed death rattle comes near the end of the film but the closure it suggests doesn't still the chilling acknowledgment of *Death of a Dunbar Girl* that this "imitation of life," this heady bundle of haughty contempt and tragic self-delusion, not only devours a sense of community but ravages the cohesiveness of family groups as well.

In *Color*, 1982, by Warrington Hudlin—one of the two videotapes included in the selections—the punishments suffered by dark-skinned blacks are matched by the anger and resentment incurred by having light skin. Two black women—one dark-skinned, the other light—tell their stories through the use of severely powerful head shots and well-spoken words. The darker woman tells of parties given by blacks in the South where they'd hold up a brown paper bag at the door and if you were darker than it was you weren't allowed in. She "hates being ugly, hates black men for thinking she's ugly and hates white people for making black men think she's ugly." The lighter woman's success as a model is limited because she is considered too light to be "really black . . . not dark enough to be an affirmative-action statistic." These two portrayals show how blacks both accept and reject the stereotypes forced upon them by white society and how difference and dissension can be repressed in order to present a "united front" against the conventional strategy of "divide and conquer." As one woman puts it, "Why expose all of this. It should be between black folks. We're not racist, we're color conscious. It's like airing our

dirty laundry in public. It's a mistake." Any group designated as "other" is familiar with this type of social construction. *Color* is an articulate and astutely pictured look at how blacks are pitted against one another in their battle to become the image of their *own* perfection.

The collection's second program showed individual blacks fighting racial stereotypes in a broader social context. In *Shipley Street,* 1981, by Jacqueline Frazier, we watch a little girl's gruesome confrontation with the rigidity of a Catholic education and its attendant racism. Like many other works in this series it focuses on the oppressive role that religion can play in the lives of those exempt from the more concrete manifestations of the sublime. *The Sky Is Gray,* 1980, by Stan Lathan, shows us the struggle for self-esteem in the segregated South of the '40s. A journey from the black quarters into town takes a mother and son down a sinuous path of tactical evasions where they quickly use up the sparse allowances that America grants them.

The third program showed "how black filmmakers have used formal cinematic devices such as montage, flashbacks and dream sequences to solve the problems of coding." In *A Dream Is What You Wake Up From,* 1979, Carolyn Johnson and Larry Bullard incorporate episodic dramatizations and cinematic self-critique into their scrutiny of the black family and the place of women within the social hierarchy. The action gingerly shifts from speeches in meeting halls to words spoken over kitchen tables, from the leanness of housing projects to the suburban split-level dream. The camera pans over a Christmas morning scene as cute kids open cute presents in a cute living room while a voice-over summons up "the dream of free love and store-

bought struggle." A middle-class businessman speaks obsessively of his plans for his family, invoking words like "feasibility" and "implementation," while his wife, eyes cast downward, picks the lint off her pants. A kid at a day-care center is asked what her mother does and she matter-of-factly replies, "My mommy does hard work and gets black and blue." Johnson and Bullard stack these moments into a docudrama-like amalgam of segmented choruses which deftly juggle the intimacy of the interior with the jaunty cruisings of exteriority.

All of the works in this series help to displace the conventional representation of blacks on the screen. The problem, however, lies not only in the difficulty of producing such films and tapes but in a distribution system that collapses the possibility for such work to be seen. Both Snead and the Whitney should be commended for an effort that might suggest different appearances for figures that usually remain unseen.

1985

Zina
Ken McMullen

In Ken McMullen's *Ghostdance,* 1983, Leonie Mellinger and the late Pascal Ogier wandered around aimlessly but gorgeously, searching for ghosts and hearing voices. One of the voices they heard and heeded was that of Jacques Derrida, philosopher of international renown. In McMullen's *Zina,* 1985, we once again watch a ravishingly beautiful woman wander around, entranced by the real and hallucinated voice of another bastion of greatness, her daddy Leon Trotsky (played by Philip Madoc). Zina Bronstein (Domiziana Giordano) is in a bad state, alternately blurting and pouting, blond tendrils framing her stunning anguished face, looking a bit like an escapee from a Deborah Turbeville photo. When another authoritative male voice, that of her psychoanalyst, Dr. Kronfeld (Ian McKellen), suggests that she should get a hold of herself, she despairingly replies, "Get a hold of what? I'm selfless . . . the good-for-nothing daughter of the most important man of our time."

From selfless good-for-nothingness to the black holes of ghostdom, McMullen consistently focuses his considerable cinematic expertise on the notion of absence, on its disembodied yet palpable materialization in the form of spirit beings and fugitive memories, and its swampy demi-emergence in that repository of gooily exotic instinct: women. In *Zina,* McMullen engages a threefold agenda. First, he characterizes Bronstein as a tormented analysand, a stunning misfit who plays bag lady in art galleries and at family get-togethers. Sliding toward suicide,

she struggles with the demons that people the empty space left by her father's exile from his family and his homeland. Second, McMullen has researched Trotsky's writings, Bronstein's letters, and Isaac Deutscher's three-part biography of Trotsky—*The Prophet Armed* (1954), *The Prophet Unarmed* (1959), and *The Prophet Outcast* (1963)—in order to set the scene both historically and politically for his life and banishment. Establishing this procedure early on, *Zina*'s pre-credit sequence sports a list of events that historically grounds the film and positions its narrative unravelment.

McMullen's third approach is to parallel this narrative with the pattern of classic tragedy, the conventional "battle between instinct and reason" riff. It's almost as if he wanted to give this damsel's sob story more weight by anchoring it to the "important" procedures of the epic genre. According to McMullen, he evoked the "epic" in order to have political and social events act similarly to the way battle scenes function in Shakespearean tragedy. What a bright boy! He collapses the multiplicities of social life into conventional binary narrative devices, as if a critique of the classic and epic form would be quite unheard of. And although the film takes on the gloss of multiple shufflings and displacements, this "look" is just another stylistic appropriation obscuring McMullen's uncritical investment in the power of master genres, master discourses, and masterpieces. Perhaps thankfully, rather than remaining content with dry avant-garde illustrations of theory, he juices up his cinematic items with continental philosopher kings and glamorous female movie stars, even adding more than a dollop of contempo feminist and psychoanalytic concerns.

Zina Bronstein was a young Jewish woman living in despair as the forces of Nazism were consolidating around her. Trotsky, exiled by two repressive regimes, Czarist and Stalinist, provides the film with an analysis of National Socialism that resonates with chilling accuracy. Their words, through voice-over visual reenactment, lend *Zina* its strength, its willingness to question the present by reminding us of the past. At a time when the notion of histories is being handily and dangerously evacuated, this film could have served as a compelling reminder. That it too often resembles a poetically flashy conceit, a neat and arty docudrama for enlightened academics, is really too bad.

1986

Corny Stories
Kim Ingraham

Vertigo
(Three Character Descriptions)
Rea Tajiri

Sentiment and refinement—one a process and a state of mind that is vulnerable to stereotype and primed for perpetual manipulation; the other a closure that locks the heady sweetness of good taste into the stratospheres of high-toned acquisition. Considerations of these two notions motor the video work of Kim Ingraham and Rea Tajiri, with Ingraham splashing around the soppy marshes of sentiment, while Tajiri acridly eyes the encapsulations of esthetics, genre, and commodity.

Overflowing with bulky depictions of sticky romantic "scenes" and chilling parodies of society's dispensations for its marginal members, Ingraham's ironic commentaries twist and tangle conventional, emotively charged presentations, dragging the soap opera, the tear-jerker, and the telethon into a hyperbolic magnification of their already ludicrous brand of display. In *Corny Stories,* 1987, she focuses on the seemingly inexhaustible antics of the empathetic device, that range of techniques that exploit the spectator's "feelings." The tape opens with a shot of a folksinger wailing and strumming his guitar, which introduces a series of episodic segments labeled "Shining Examples," "Triumph in the Face of Death," "Lost Hopes and Broken Dreams," and "Lasting Regrets," each featuring a talking head telling a sad story that exudes hope in the face of heartbreak. We learn of a woman, whose brother has been in a serious car accident, taking inspiration from her childhood memory of a little boy with a wooden leg; of two young girls

who, stricken with diseases that impair their ability to speak (cerebral palsy and spina bifida), communicate in their own seemingly garbled verbal language; of a Vietnam vet who decides to adopt a young Vietnamese child, only to find that she has just been killed in an orphanage bombing; and of Pearline, a young victim of a poor and decimated home, who was thrown out the window by her mother's boyfriend. These fictive vignettes are sandwiched between 40-second interludes that alternate between the opening folksinger and a young woman sitting on a park bench singing, each time doing a different song—James Taylor's "Carolina in My Mind," Bob Dylan's "It's Alright, Ma (I'm Only Bleeding)," etc.

But what is to be made of all this? Is this an honest appeal to our concerns and feelings of "universal humanity," or a mean-spirited mimicry of the afflictions of biology and social circumstance that affect human beings? There is an edge to Ingraham's work, a keenly slippery jettisoning of decorous "goodness," which puts into question the hollow gestures that constitute the notion of benevolence in contemporary culture. Rather than engaging in a parody subsumed by its original model, Ingraham (like Eric Bogosian at his best) plays the jagged edge, pushing a bit further and flirting with the extremities of the genteel while stopping just short of contempt.

Although Rea Tajiri's work eschews a parodic relationship to conventional narrative, she shares with Ingraham an interest in ironic, expository representations. In *Vertigo: (Three Character Descriptions),* 1987, she constructs an elegantly episodic rebus that integrates a trio of crawling written texts with an enveloping sound track. We watch words inch up the screen and tell

us of three images: *Giuditta* (Judith [and Her Maidservant], ca. 1600), a painting by Cristofano Allori; a photograph of Lu Hsun on his way to deliver a speech at Kwanghua University, Shanghai, in 1927; and a photograph of a jewel box made by Archibald Knox around 1900. Not coincidentally, we are informed by the text that all these images are reproduced as postcards, some of which are on sale at various museum gift shops. But we see neither the artful objects themselves nor the postcard reproductions of them. We are dependent on words to help us construct these images and objects in our mind's eye, sort of like a paint-by-numbers radio show during which we see words rather than hear them. Tajiri juggles our expectations of informational delivery, collapsing picture into text and allowing sound to do the shuffling. This slight discombobulation begins to suggest the "vertigo" of the title, but the connection is literalized when we discover that the music accompanying Tajiri's textual descriptions is none other than snippets from Bernard Herrmann's score for Hitchcock's *Vertigo*. Words describe Allori's painting of a woman holding a decapitated head as the music engages in slowly escalating rhythmic interventions; her dress is detailed to us amidst the baroqueness of teasingly phrased gallops. We read of Lu Hsun's physical demeanor as the melodic pace quickens, and the silver filigree festooning Archibald Knox's jewel box is veneered by quiveringly soppy strings. Tajiri foregrounds the score's capability to provide emphasis, change meaning, and provide an ironic counterpoint to the literalness of the text. Her subtraction and repositioning of the sound track from its original site casts critically comedic aspersions on the traditional formulas of film melo-

drama and its subsequent genres. She reminds us not only of the functions and refinements of sight and sound but of the interpretation, reproduction, and commodification of historical artifacts and estheticized objects.

1986

Fury Is a Feeling Too
Cynthia Beatt

Fury Is a Feeling Too, 1983, is a film about the mouth and eyes of a foreigner. The mouth must re-form itself by embracing new sounds and sometimes uncomfortable modulations. The eyes view apparently familiar social phyla which on closer inspection disclose specifically different national histories. It is this position of "foreigner" that Cynthia Beatt seems to occupy. A British subject born in Kingston, Jamaica, she lived in the Fiji Islands, was raised in England, and moved to Berlin in 1975. *Fury Is a Feeling Too,* which she directed, wrote, and appears in, is a semi-autobiographical encapsulation of her relationship to Germany—a sort of cranky, witty, intellectually astute rendition of a Frommer's Guide replete with architectural treats and warnings about the unwieldy temperaments of the natives. Exterior shots meander up and down buildings with a choppy glance which traipses around design details and juts up to the crisp demarcation that announces the meeting of structure and sky. Reminded that "a house is a text through which one may read another era," we consider not only the specificities and romantic rigor of German design, but also the way it defines Berlin's difference from other European cities and how the city itself has become a bifurcated amalgam of two economic and social regimes.

Beatt's interior shots show us various conversational arrangements, from rhythmic soliloquies to anecdotal duets to aggravated triangulations, all attesting to certain stereotypical

assumptions about German life. A man in a bar bemoans the presence of the Turks. A woman complains about the meanness of a saleslady who seemed to be saying to her, "How dare you ask for a moss green bathrobe!" All this seems indicative of an intolerant society: "A country where a spot on your jacket is worse than a world war," where people are "satisfied with their sickness and heartlessness" and "justify nastiness to the bitter end." Beatt also struggles with the intricacies of a language whose vernacular subtleties, like those of the culture in general, she either disdains or finds totally unavailable to her. She is contained by what she detests and mourns the loss of other structures and texts which she has called her own. *Fury Is a Feeling Too* delineates these divided sentiments about a divided city with clarity and economy, and joins the "first contact" of the foreigner with the "second nature" of the native.

1985

Portrait of Jason
The Connection
Savage/Love
Shirley Clarke

One hand on hip, drink perched precariously in the other, he declares, "I was wild, black and crazy and I had white-boy fever." Collapsing into a confidential baritone, he whispers "I love you Richard, trust me. I'm going to fuck you up." We are watching Jason Holiday (born Aaron Paine), a middle-aged black male hustler, as he alternates between poignant reflection and spasmodic giggling fits. Acting out for the camera like Veroushka on a roll, he is an intelligent man playing cat and mouse with his own sanity. And this Jason is not just a struggling, troubled guy, but a cinematic object, good material to hinge a movie on, a supplier of entertaining pathos for Shirley Clarke's voracious camera. *Portrait of Jason* (1967) is both a powerful stare at a human being as a collection of symptoms and a canny encapsulation of the monologue form. Its sparsely elegant shooting hones in on Jason like a thirsty bloodhound. And it is this predatoriness that renders the film painfully naive and exploitative around the issues of blackness and homosexuality. For Jason's performance is cued by an off-camera chorus of suggestions and directives: "Hey Jase, do one of the nightclub bits"; "What else have you got?"; "C'mon Jason, tell the one about . . ." These requests, like Clarke's audible directorial comments ("fade to black," "keep the sound going"), function critically as reminders to the viewers that the spectacle before them is a construction of dictated passages, an amalgam of pictures and words that comprise a movie. Together with episodic

headshot dissolves and misfocusings, they display the film's Brechtian fluency. But these views and coaxings also work to foreground Jason's objectification and to duplicate conventional viewing procedures. With all its power and acuity, *Portrait of Jason* repeats some of the operations that have oppressed and marginalized this black homosexual man. Putting his verboten otherness "to good use," the filmmaker plies him with reefer and drink to get "interesting" material, to get him to deliver the goods, to make for a good movie.

While *Portrait of Jason* exposes Clarke's disturbing indulgence in cultural and racial tourism, *The Connection* (1961) allows her to comment critically on this unfortunate game plan. Based on a play by Jack Gelber and smartly shot by Arthur J. Ornitz, it shows a director's attempts to film a bunch of junkies in their "natural habitat," a very dressed-down loft pad. This movie-within-a-movie format allows an examination of the psychological and filmic apparatus that comprise the liberal documentary genre. Facing the camera (and probably cued by George Burns as much as by Brecht) Clarke's "director" tells us that he is not interested in making a Hollywood picture but is trying to make "an honest human document." The junkies in turn stare at the camera (and the audience) and protest, "What do you think, we live in a freak show?" They taunt the director about his naiveté and manipulative voyeurism until he screams "Stop looking at me!" and aims his camera at them as if it were a hot-to-trot Colt .45. This recognition of photography and the cinema as the victory of the image over the actual makes *The Connection* a rigorous examination of not only bohemian adventurism (the director's picaresque sight-seeing through the op-

pressions of race and class) but of the subject/object relations in much documentary production.

But what enables *The Connection* to deliver its words and images loud and clear is a device which is also the motor of *Portrait of Jason* and Clarke's newer works: the talking head having its say, and to some extent its way, with the spectator. The direct address of the tight and medium frontal shot allows Clarke to revel in the informational, the literary, the theatrical. A monologuing man is the central figure of both *Savage/Love* (1981) and *Tongues* (1982), Clarke's recent video collaborations with Sam Shepard and Joseph Chaikin.

Ostensibly about Love and Death at the post office, *Savage/Love* frames Chaikin as he speaks, sputters, and gestures, spilling Shepard's savvy speech in accelerated dribs and drabs. The incessant self-crit tumbling out of Chaikin's mouth is accompanied by a lone flutist who is shown playing a riff that sounds like the intro to "The Open Mind," a bastion of old-time cultural television. Chaikin recites an outline of reactions and feelings which prime him for a romance with the imaginary: "Which presentation of myself will make you want to touch?"; "When I sit like this do you see me brave?" Likewise, in *Tongues,* Chaikin's talking head describes the steps "from mourning to being completely dead." This soapboxing creates an excess of characterological flourishes and serves merely to showcase Chaikin's virtuosities and the eccentricities of the avant-garde delivery. But the main difficulty with these new works lies not in their resemblance to early-'60s cultural television, but in the effort to disguise that resemblance in a mélange of contemporary video special effects. This overkill is not only

silly but manages to trounce the power of Shepard's brilliant speechwriting and Chaikin's nimble vignetting. Clarke thumbs through a catalogue of video trickery with the hunger of a toddler salivating at the sight of a cupcake. Chaikin's face is jarred out of the directness of the talking head and stretched this way and that. Poof! he's shaped like a square and then, oh wow, now he's a circle! Clarke rolls out the red carpet for every trick in the book and the results wear the kind of disappointment that only novelty can induce.

What has sustained Clarke through twenty-five years of independent filmmaking has been a clarity of vision and an articulateness of speech. Her films have sent messages from the margins to a larger audience and made those who are perpetually absent from "polite society" present on the screen. The recent videos are clearly based on the strengths of this earlier activity, but are undermined by her ill-considered submersion in tech trickery. It is to be hoped that this will give way to the more economic approach to the image that marked her earlier films.

1984

The Golden Eighties
Chantal Akerman

Heart Like a Wheel
Jonathan Kaplan

With a number of exceptions, this year's New York Film Festival was comprised of a cinema entertaining that great theme of themes: man's terrible struggle with his terrible freedom. The "great" European directors Jean-Luc Godard, Alain Resnais, Alain Tanner, Andrei Tarkovsky, and Andrzej Wajda portray the gargantuan responsibility of it all: the painful quandaries of history, the infinity of the spiritual, the charms of esthetic formality, the romantic immortalisms of sexual otherness. Carrying the weight of the world on their shoulders, these are "great" and ambitious men, artists who mediate between God and the public—and who, in doing so, have incidentally refined the art of making the "perfect" festival film. Compared to their eloquent exercises in florid pretense, Robert Altman's *Streamers* and Francis Coppola's *Rumble Fish* read like refreshingly forthright expositions of the classic boy-bonding riff. Both films seem admirably stuck in the concrete and suggest a criticality that ironically eludes the work of their Euro-intellectual brothers, who are just too busy tracking down metaphor and apocalypse under every pebble, between each gracious fold of satin, and at the tip of every rosy-pink tit. But located even further from this aforementioned grandiosity are Chantal Akerman's *The Golden Eighties* and Jonathan Kaplan's *Heart Like a Wheel*.

Like Godard's *Passion, The Golden Eighties* looks at the assemblage of material and intellectual goods that comprise a

movie. But where Godard comfortably segues into his familiar narcissistic harangues and self-congratulatory intellectualisms, Akerman abides by a terse economics. She tells us of preparation and product, of the refinements that accumulate to produce representation. Unlike her previous *Toute Une Nuit* (1981–82), which indulges in a brand of Hallmark Card avant-gardism, *The Golden Eighties* melds the stylistics and intellectual dispensations available to avant-garde practice with the conventions of popular cinema. The film is divided into four parts, beginning with a section called "Audition." Shot in video and blown up to 35 mm, this is a litany of performers' tryouts which hone the multiple to the singular and conflate the notions of reduction and portrayal. As a sampler of characterological possibility, it allows each hopeful actress and actor to coat their lines with a purportedly personalized intonation. The words they speak and sing are the staples of a familiar mode, that of the movie musical, and through their repeated shadings one can say that Akerman defoliates a genre, encouraging the viewer to consider the construction of illusion. However, it should be noted that this entire section consists of avant-garde maneuvers, which are also deserving of certain deconstructions. This does not occur here.

The next three segments, titled "Project 2," "Project 3," and "The Golden Eighties," reconnect and formalize the deconstructions of "Audition." Located in a soda shop, a beauty parlor, and a dress shop, they emerge in a moment of minor astonishment. As "Audition" ends, the curtains framing the screen widen as the video/film image gives way to the precisely shiny flourishes of widescreen 35 mm. This can be read as a reward to the patient spectator (perhaps unschooled in the ap-

preciation of the avant-garde) who sat out the first hour of non-resolution in both the image and the narrative. And this meeting of the fuzzily unkempt video image with the snazziness of cinematic color illustrates how novelty invades the realm of visual pleasure, how formality envelops preparation in what is seen as the fixity of the image. So Akerman's melodramatically melodic declarations of lost love are siphoned through a repetitive procedure which empties them of their "truth," of their ability to solicit the empathetic response. Though employing a different approach than the earlier *Jeanne Dielman, 23 Quai du Commerce, 1080 Bruxelles* (1975), or *Les Rendez-vous D'Anna* (1978), *The Golden Eighties* can be read as another of Akerman's critical positionings vis-à-vis the seamlessness of the image and the figures that embody it.

In relation to this last point the inclusion of Akerman herself, wrestling with the specificities of recording techniques and directorial gestures, connects again with Godard's autobiopic "man and his machines" number. But where he displays a plodding self-seriousness, she presents herself with a sort of lilting irony which admittedly comes perilously close to cutesiness. In ending the film with a pan of the city of Brussels, Akerman acknowledges the world beyond the interior encapsulations of the big studio musical. But she also suggests that cinema is an accumulation of codes ripe for collapsing. The strength of *The Golden Eighties* is its ability to cast aspersions on movies and their power to perpetuate what we look at and what we look like. Its presence amidst the festival's "masterpieces of cinema" will hopefully encourage viewers to question what we mean when we call something "great."

Rather than interrupting narrative, Kaplan prefers to get on with it. He is a storyteller who wastes no words, using the most conventional narrative form to insinuate characters and situations usually absent from representation. *Heart Like a Wheel* follows Shirley Muldowney (Bonnie Bedelia) as she progresses from a young bride with a yen for fast cars to the only three-time world-championship winner in National Hot Rod Association history. Melding the sentiment of the bio-pic with the edge of the sports film, Kaplan succeeds in showing us a woman's attempt to define herself both as a professional racer and as a wife and mother. The latter goal, however, eludes her, as she slips away from her initially supportive but increasingly threatened husband (Leo Rossi) toward the flirtatious antics of fellow driver Connie Kalitta (Beau Bridges). But whatever the sexual involvement, Shirley struggles to keep her balance, to walk the thin line between isolation and masochistic deference.

Kaplan has wryly noted that most Hollywood films with a feminist slant concern women making choices about which New York townhouse to live in. Clearly, in *Heart Like a Wheel* he is interested in a feminist depiction that engages questions of class. His workman-like films are quick to establish the relationship between economics and the embellishments or hardships of social life. Taking great pleasure in American views and vernaculars, his astute sightings range from the period details of popular music and architecture to regional subtleties, like the change in light and scale from the dense greenery of New York State to the big, bright sky of Southern California.

Lacking the stunning cinematography and elegance of the European and Hollywood blockbusters, *Heart Like a Wheel* and

Kaplan's earlier *Over the Edge* (1982) connect to the familiarities of the TV film. Considering this, it is ironic that these accessible works have had difficulty finding their audience. Perhaps with the help of an intelligent distribution strategy they can be allowed to do their work. Kaplan's movies are frequently alluded to as "small," and their ambitions surely differ from the European art films that dominate the festival. Eschewing man's terrible struggle with his terrible freedom, Kaplan never indulges in "deep," ponderous heroics. *Heart Like a Wheel* cuts through the grease and hits 85 in a 55 MPH zone with a woman at the wheel.

1983

The New York Film Festival

The New York Film Festival roster was again awash with continental *sexualité;* saucy tidbits ripe for American connoisseurial delectation. A glance at the menu tells it all: films about nuns in a convent or young girls discovering their repressedly churning libidos are certainly not dissimilar to last year's young girls discovering their newly spiraling libidos. Not only is it problematic to speak of a national cinema, but it would be a mistake to categorize French films, or any other, on the basis of a few arty export flicks chosen by a coterie of festival directors and critics. But certain observations can be made, I hope, without resorting to rigid categorizations.

A number of recent American films have thankfully left predictable and stereotypical sex romps behind, and entered a terrain in which relationships, both romantic and platonic, are defined by and share the spotlight with the culture that contains them. In other words, human connections exist, not in some steamy never-never land but rather in an America constructed of sex, money, race, labor, leisure, wealth, poverty, and rock 'n' roll, to name a few influences. Stories unfold within an anthropologically excavated tableau in which characters enact a sexuality determined by shopping habits, musical tastes, and ways of living and dying.

Francis Ford Coppola's *Peggy Sue Got Married,* Jim Jarmusch's *Down by Law,* and David Byrne's *True Stories* all carry the markings of this socially studied breed of American film.

Peggy Sue Got Married is a nostalgically manipulative launch into the wild and crazy lapses of time travel, substituting Kathleen Turner's throaty world-weary woman for *Back to the Future*'s cute-boy teen voyager. Although the film is more than a bit soggy, its savvy sex-role reversals and Smithsonian-like cultural exhibitionism make it a simple gooey pleasure.

Down by Law, gorgeous, slight, and determinately anti-effervescent, is another of Jim Jarmusch's homages to the notion of "the white negro." Y'know, all those everything-is-everything honky-guy attempts to appropriate what they perceive to be the apex of cool. The jail scene featuring Tom Waits in a hair net and John Lurie desperately pursing his lips in order to make them appear fuller says it all.

True Stories is as stunningly flat as the landscape it glides through. Casting aside the dramatic crescendos of vertical narrative, David Byrne's amble through Virgil, Texas, is the apotheosis of the travel film, a touristic glance at the "other" as it shops, works, and celebrates its way through its heartland habitat. Replete with Stetson and string tie, Byrne is the quintessential tour guide, a gosh-darn combo of Mr. Rogers and Marlin Perkins. An apt stance, since his fictive burg of Virgil is indeed pictured as a conflation of "Mr. Rogers' Neighborhood" and "Zoo Parade."

True Stories is, among other things, a bunch of smashing music videos strung together by a draggy narrative that functions like a plodding necklace of conjunctions. Ironically, Byrne's squeaky-clean accomplishment has the feel of a porno film, during which the audience survives the interminably arrested plot in anticipation of the next penetration shot. So if the

music segments are glimpses into the national interior, then Ed Lachman's horizontal glance at tract houses and shopping malls supplies us with a distanced view of the national corpus. We watch parades chock-full of lawn mower brigades, Shriners in miniature cars, and low riders. We see auctioneers sing and yodel and assembly lines percolate with giggles and gossip. And we again watch television via a skillful appropriation of some *very* familiar video moments. *True Stories* is an obvious extension of the last decade of smashingly distanced Talking Heads production. To see it as a kind of aw-shucks, darn-gorgeous salute to wacky Americana would be a goof. No matter how much Byrne wants to believe that he has ferreted out a smidgen of compassion in that cold smart noggin of his, it remains amusingly clear that he is a failure at genteel humanism. His Virgil exudes a kind of madhouse allure in which he, the attendant, gently shows the inmates to their cells. That the title suggests that Byrne seriously believes in any notion of "truth" let alone any brand of "story," is a cute joke. How come all the brightest boys want to be the man who fell to earth?

1986

Mammame
Raul Ruiz

It's always been pretty obvious that Raul Ruiz has a terrific eye, and perhaps less acknowledged that he has a great mouth. All his films are marked by virtuoso verbal eruptions, a scripting that skids from aphorism to sophism to humorism. This is most apparent in *Roof of the Whale,* 1982, where he is freed from his crush on avant-garde linguistic turns and self-congratulatory dazzle and constructs a work that is at once gorgeous, grim, and giggly. So it is with much curiosity that we approach *Mammame,* 1986. Here is Ruiz without words, Ruiz and the document, Ruiz and the body. *Mammame* is a film of a dance by the French choreographer Jean-Claude Gallotta, whose tribes of dancers tend to work space like disgruntled molecules, tumbling, shifting, and passing time on the way to exhaustion.

The "dance on film" genre is a skittishly predictable one, which generally respects the proscenium view, reducing dancers to tiny Thumbelinas, shrunken but bouncing denizens of a minuscule world. Locked in static long shots and literalized linearity, they are genericized, turned into "dancers on film," robbed of their excesses and particularities, exiled far from the shameless revelations of lascivious tight shots and roving ogles. Ruiz, of course, will have none of this. His long shots are *really* long, shrinking his dancers to stage size with a kind of pithy irony, knowingly foregrounding the genericization of their forms. His incessant gamesmanship involves a playful recognition of the camera's ability to giganticize and miniaturize, to

over- and underwhelm. And where "dance film" shows us figures, Ruiz shows us bodies, bringing us "up close and personal," making us check out niches and crevices, making us privy to the ambient sound of physical exertions. His camera revels in crotch shots and looming profiles plunked on the floors of stark white chambers that recall Bill Brandt's photo work of the '60s. The austere settings sport only stray telephones, scattered lemons, and Gallotta's troupe of four women and five men, who indulge in episodic mini-dramas and concise, predictable sexual vignettes. Language relinquishes its place to barely audible gurgles and sighs, an Esperanto of affection and duress wrapped in breathy annunciations and punctuated by rhythmic moans. Wrists are clasped, clavicles bonded, hips soldered and disengaged with the regularity of ailing mechanisms at the end of the machine age.

On the up side, Ruiz and Gallotta work to embody the stereotypes of "dance film," to bloat the empty figures of stylistic precedent with biological effluvia. Refusing to lay down and play dead in the face of the genre's gelled visuals, they work to dishevel the notion of the document and reportage by shuffling setups and indulging in an antic process of splicing, cutting, and pasting. On the down side, they're hell-bent on "transgression," making *Mammame* exude shock value like cheap perfume. This avant pretense runs so thick that it evokes the old "Saturday Night Live": one almost expects Dan Ackroyd to strut onto the set as Leonard Pinth Garnell and proceed to introduce this week's episode of "Bad Conceptual Art." In addition, one can't help but wonder if this 65-minute film couldn't be consolidated into an even more economical render-

ing of Gallotta's work. A filmic proceeding does not have the same corporeal charge as live performance, carrying with it an altered sense of time and its unravelings. Perhaps Ruiz and Gallotta could have gone further in displacing "the document" by playing even faster and looser with the notions of replication and verisimilitude. By clipping and deliteralizing the site of "the recital," they could have more potently foregrounded the picturing of moving bodies while still allowing film to strut its stuff.

1988

The Trap Door
Beth B. and Scott B.

A hero is put upon. He works hard and is not rewarded. He is manipulated by cruel bosses. He is rejected by his girlfriend. He is yelled at. He is seduced by girls with baroque stories and crazy ideas. He is victimized by psychiatry. He's just a guy. Jeremy (the hero), who ponders his way through *The Trap Door,* the latest film by Beth B. and Scott B., has all the wonder and reticence of Beaver Cleaver. He's cute as a button, gosh darn naive, and sports that lucky kind of face, as comfy on the assembly line as at the country club. (Hollywood's rules of representation have not been wasted on the B's.) As a worker, he is reduced to a powerless jerk and then dismissed. Accused of lateness and other heinous crimes, he is chided by a company boss whose merciless expedience turns a deaf ear to Jeremy's accusations of corporate callousness and profiteering. Fired and depressed, he handily manages to get dumped by his girlfriend, who chose to substitute his philosophical ramblings about what a real kiss is ("I'm not sure what's real anymore") with the non-philosophical but willing mouth of some other guy.

As opposed to the modish sleaze and baby violence of *Black Box* and *The Avengers, The Trap Door* invites the spectator to consider the act and idea of working. In this way it resembles *Letters to Dad* in its joining of subculture demi-luminaries and stories of "public concern." What seemed right in *Letters to Dad* was its economy of image, its lean way of picturing and story- ing: its doubling of a "felt" text into the mouths of cool cats.

All these films insinuate certain words and positions as signifiers of a kind of politicized "we careness," whether through picaresque terrorist poses, ironicized distance, or a relentlessly overdetermined zaniness.

These stylistics are symptomatic of an already periodized group of activities. To a generation steeped in movies and rock and roll, it was a pleasure to want out from the strictures of Greenbergian nuance and conceptual pataphysics: to finally admit that they never wanted to go to the Rothko Chapel, that they fell asleep watching the filmic transformation of a tree through summer, fall, winter, and spring. To these artists, the return to imagery and to the play and disruption of narrative were welcome moves. They considered the masochism of the spectator to be a drag and their production echoed these concerns. This confluence of ideas and activities around film and rock and roll created a lasciviously ironic gutter salon, whose work was the recipient of uncritical, desperately benevolent journalistic praise. Almost all this activity enlisted a kind of doubled movement, combining an appropriation of affliction (picaresque adventures in poverty, a cruel mimicry of minority and workers' "struggles") with the bright-eyed and bushy-tailed careerist ambitions of privileged white youth. Irony is made to function as a detour around the embarrassment of declaration and the toil of analysis, resulting in an inept but cutesy, juvenile parody.

Parodic commentary has the power to disrupt the "naturalness" of social life and can use laughter to question the cultural conditions which construct and contain us. But in much of this recent film work, parody's power dissolves into a gaggle

of facetious, unfunny kidstuff. All the whips and sunglasses in the world can't conjure up the purported "political concern" of these silly but harmless trifles. The fact that the B's and their peers have traveled even this far on mere promise is proof that there is an audience of viewers who are hungry for powerfully funny yet critically engaged films. These are not they.

1979

A Question of Silence
Marleen Gorris

The agenda of narrative film seldom allows for any imperti-
nence or surprise, for any disruption of the powers of repre-
sentation. Thanks to a number of canny minds still at work in
commercial cinema both in America and Europe, we can catch
slight glimpses of slippages, but their best chance of congealing
into broader representations is probably within the framework
of independent film. A powerful example of this mode of dis-
location is Chantal Akerman's *Jeanne Dielman, 23 Quai du Com-
merce, 1080 Bruxelles,* an extraordinary gaze into a social (and
unsocial) life. Another is *A Question of Silence,* a first feature by
Dutch filmmaker Marleen Gorris shown in the "New Direc-
tors/New Films" series organized by the Museum of Modern
Art and the Film Society of Lincoln Center. Although lacking
the esthetic achievement of Akerman's work, *A Question of
Silence* is a riveting exposition, combining baroque narrative
flourish with forthright confrontation.

It tells the story of three women who are taken into police
custody for their part in a particularly intense collaboration—
that of murder. A housewife is removed from the sullen inte-
riority of a messy apartment, a barmaid exits from a world of
tough-girl banter and forced frivolity, and a secretary merely
uncrosses her sleekly stockinged legs and strolls out of the office.
Having ended the life of a vigilantly sadistic male boutique
manager, the three leave their casually stereotyped encapsula-

tions and enter a far more explicit mode of containment: imprisonment.

Here they are introduced to a court-appointed psychiatrist assigned to determine their sanity or lack of it. As the film progresses, we watch her progress from a sympathetic but professionally distanced investigator to a woman intent on challenging the repressive formalities of the judicial system, thereby threatening the very notion of professionalism which has sanctioned her function in the world of men.

The story's advance is constantly displaced by flashbacks which allow for an alternation between the duress of incarceration and the scene of the crime. The enactment of the murder, though discreetly specific, in no way dominates the film, in no way exploits the women's actions, but rather sets the scene sharply for the film's most powerful unraveling: the women's day in court. Reminiscent of Werner Scroeter's virtuoso depiction of the madness of judicial authority in *Palermo oder Wolfsburg,* 1979–80, this scene contrasts the male court officials' pompous surety of knowledge with the psychiatrist's articulate critical pronouncements. In an interesting reversal, she counters the men's increasingly emotional responses with a coolness of delivery that turns the defendants' homicidal action into nothing less than an exercise in logic. Her verbal transgressions threaten not only the ossified decorum of the court, but also her alliance with her patronizing husband, an ambitious lawyer who fears that her "impertinence" will endanger his own career. Yet she persists in her measured contradictions of the notions of sanity and morality as they are inscribed within culture, remind-

ing the court of the hierarchical choreographies of class and gender and their resultant marginalities.

As the debate continues, a sound is heard brewing in the courtroom—an insistent murmur which slowly escalates into a cascade of giggles and laughter, into a flood of ticklish escapes from the somber rigor of "reason." And the laughers are, of course, the women. Not just the defendants and the psychiatrist, but every woman in the courtroom. Interestingly, at each screening of the film that I attended, this infectious rupture spread to the theater audience, producing a moment of stunning solidarity. Back on the screen, the court officials, their patience exhausted, announce that the case will now be tried in the absence of (laughing) women, thereby literalizing their removal from the procedures of all legal and social arrangements.

A Question of Silence is a fluent reminder of the cinema's ability not only to please us with the eloquence of formal, optical arrangements and conventional scenarios, but to critically alter the moments of our lives: to connect the suggestions of the movie theater's darkened interiority with the exteriority of public life. And in doing so, it is another step in the welcoming of female spectators into the audience of men.

1983

Frank Tashlin

Though much theoretical writing on popular movies is being done in the U.S., its initial flowering connects to an Anglo-European rapture over American physical and psychological frontierism and resulted in the elevation of Sam Fuller, Nicholas Ray, and most notably, the French enshrinement of Jerry Lewis and Frank Tashlin. That European theorists chose to allude to Tashlin's films in a dense, psychologized jargon, with references to Hegel and Heidegger, is cute (in the Jesuit sense). These strenuously serious, yet hilarious decodings are clearly examples of zany, hardworking films generating zany, hardworking ruminations which tread the line between astute analysis and intellectual fadism. (The apex of this genre of critical reckoning being *A Lexicon of Lewisian Terms* which, found in a catalogue of the 1973 Edinburgh Film Festival, glows with a ludicrous mania.)

While topicality often deals a fatal blow to weaker work, Tashlin's foregrounding of "the latest" inflates these films into gaudy, memorable intrusions of popular concern in an era rife with forgetfulness. But although they play as parodic indictments of success, illusion, the synthetic, the commodification of goods and consumers, and the rote generation of Hollywood swill, they seem to revel in the further celebration of these targets. Parody constantly conjures the demon, but in Tashlin's case, this demon isn't depleted through quotation and ridicule, but pumped up through a kind of sleazily jovial mimicry. The

films are marked by an ideological virginity, an unwillingness to engage criticism beyond funny, whiny, complaints. Nevertheless, the litany of gags and vignettes unfolds with the regularity of a pleated skirt. Tashlin's work as a cartoonist informed the films with their mechanic whimsy and mania for anthropomorphizing, both staples of the classic comedic repertoire. *The Girl Can't Help It* might purport to criticize crazy careerism and the "vulgarity" of rock and roll, but luckily winds up, instead, as a shiny, raunchy celebration of fast and loose music. *Will Success Spoil Rock Hunter?* ogles the baroque machinations and dream factory intensity of the ad industry and uncritically manages to set the viewer more lasciviously aglow than a crash course in Vance Packard's *The Hidden Persuaders*.

But the real movers of these films are the unveiling of the female statuette and the exaltation of the afflicted man/boy figure. Both genders are parodically skewed; the men are lovingly shoved into an anti-hero denouement, while the girls are spotlighted as glittering dirty jokes. Tits and ass were box office for Tashlin and, accordingly, the classic female pose, the manifesto of biological destiny, was never interrupted. The male characters, from Bob Hope and Tony Randall to Jerry Lewis, are ingratiatingly and pitifully afflicted. With Martin and Lewis, in *Hollywood or Bust* and *Artists and Models,* we see the division of the male role into a duet; a teaming of the braggart and the ironist, the smoothie and the schnook. Lewis is a brutally cute portrait of arrested development; a stunning cartoon that haltingly traipses around inadequacy and sexual naiveté. These physical and verbal meanderings are "refined" in his own subsequent films as tableaux of spastic desire. (The latest incarnation

of this image surfaces in the poignant and wacky mimicry in Fassbinder's *The Year of Thirteen Moons*.)

Tashlin understood that the extremities of melodrama soon melt into satire, and he informed his work with a frantic dislocation, a spoofy revue-like style that strings skits together at a relentless pace. This playfulness extends to the manipulation and disruption of the institutionalized cinematic forms of titles, credits, and endings. Tony Randall plays the Twentieth Century Fox theme song in the beginning of *Rock Hunter* and then announces "The title of this film is The Girl Can't Help It . . . no, we already made that!" The screen shrinks to a TV format in *Rock Hunter*, and in *The Disorderly Orderly* we see an interplay of voice and subtitles. The films also display a constant barrage of movie quotation, as in the reply of Dick Powell's secretary (in *Susan Slept Here*) who, when asked what she knows about motherhood, boasted, "I happened to have typed the script for Stella Dallas." These devices, plus the plentiful use of posters and graphic text, give Tashlin's work a tricky, wordy feel. Its novelties invert and expose the smooth scene of narration and seemingly attempt to undermine the naturalness of not only film, but the dictates of television and advertising as well. But the resulting films, however stridently brash, wind up as fat amalgams of all three. Rather than an intervention through parody, we see a compliance with and celebration of popular stereotypes, resulting, in part, from Tashlin's indictment of symptom and excusal of cause.

1979

White Dog
Sam Fuller

Film audiences are currently being inundated with a glut of dazzling special-effects movies crammed with expensively wondrous visual invention and glossily framed shots. Watching them can approximate the feeling of running head-on into the deep space of a video game. When viewed strictly as catalogues of techno-esthetic prowess they may reward us with a kind of narrow utopia of visual pleasure; unfortunately directors find it necessary to get literary—hence the usual establishment of a leaden, stereotypical narrative premise. These movies sport blazing beginnings which soon crumble into tired soap operas oozing with "human" sentiment, and, in the case of *Blade Runner,* directed by Ridley Scott, end up suspiciously like demi-androidal steals from Claude Lelouch. Like disappointing one-night stands, they are gorgeous and stupid; they are seldom ambitious, complex, or even silly.

Ambitious, complex, silly (and inexpensive) films have always been the domain of Sam Fuller. His latest, *White Dog,* is adapted from a story by Romain Gary and was scripted by Fuller and Curtis Hanson. Thankfully, it is a throwback to his most successful earlier works in its eccentric, audacious tackling of some of his favorite themes—the heroic assignment and the contradiction between the apparent and the actual.

Julie (Kristy McNichol), an aspiring actress, is cruising the Hollywood hills one night and hits a beautiful, white German shepherd dog. Shaken by the accident, she rushes him to a

veterinarian. An aerial shot delineates the animal's body spread limply across the operating table, and the audience is hooked. The doggie pulls through and Julie dubiously lets him crash at her place for a while. The attachment is cemented when he rescues her from the hands of a prowler. Meanwhile her boyfriend (Jameson Parker), who at first encouraged her acceptance of the pet, begins to feel alienated—justifiably, since the dog is cuter and far more interesting than he is.

The film loses its cloying, Lassie-like character when we learn that the pooch's nights out result in a series of vicious mutilations. He is taken to an animal trainer (Paul Winfield), a heroic black man, who explains that the "pet" is not only an attack dog, but a "white dog," a canine trained since puppyhood to assault and kill black people. The bulk of the film pictures the trainer's crusade to "break" the white dog, to rupture the pattern of violence. This grueling deprogramming procedure often segues into didactic, docudrama-like lectures on the tyranny and oppression of racism in American culture. The launch into the expository mode, the dialogue crammed with the economy of the slogan, the politic of the headline, is pure Fuller. Similarly, the canny use of the dog displays the director's journalistic élan, his understanding of the power of the tabloid overture (*"Kitten stuck in drainpipe!"*) Thanks to Bruce Surtees' oddly elegant camera work, the canine is everywhere—caressed in tight close-ups, framed in slow-motion romps, profiled muzzle-to-nose with his trainer, glued to the TV watching war movies. Not unlike Steven Spielberg in his use of little E.T., Fuller seduces the viewer into an orgy of anthropomorphism.

The issue of racism is approached with both candor and cynicism. Although he desires a belief in the notion of justice, Fuller easily succumbs to an essentialist vision of life; his heroes and heroines inevitably meet their comeuppances when they confront the "nature" of life's "basic" confusions and contradictions. Winfield's character is another in the director's long line of headstrong individuals, eking out a life of eccentric exemplariness on the peripheries of convention. His failure to change the dog (which he refers to as a four-legged time bomb) supports Fuller's investment in the seemingly indelible quality of the racist imprint. This frantic despair makes for an edgy, at times silly, yet interesting film, and certainly not a racist one. Looking one minute like a jolly made-for-TV romp through the Hollywood hills (or a bad day in the life of Kristy McNichol) and the next like a strangely demented newsreel stringing together extreme close-ups of black skin, white skin, fur, and blood, it is a strangely disconcerting attempt to reassure the viewer that all is not well with the world.

1982

Position Papers

Not Nothing

You are walking down the street but nothing is familiar. You are a child who swallowed her parents too soon; a brat, a blank subject. You are the violence of mourning objects which you no longer want. You are the end of desire. You would not be this nothing if it wasn't for courtliness. In other words, religion, morality, and ideology are the purification and repression of your nothing. In other words, romance is a memory of nothing which won't take no for an answer and fills the hole with a something called metaphor, which is what writers use so they won't be frightened to death: to nothing. You ransack authority by stealing the works of others, but you are a sloppy copyist because fidelity would make you less of a nothing. You say you are an unbeloved infidel. When you are the most nothing you say "I want you inside of me." And when you are even more nothing you say "Hit me harder so I won't feel it." As a kind of formal exercise, you become a murderer without a corpse, a lover without an object, a corpse without a murderer. Your quick change artistry is a crafty dance of guises: coverups for that which you know best: nothing. And all the books, sex, movies, charm bracelets, and dope in the world can't cover up this nothing. And you know this very well since you are a librarian, a whore, a director, a jeweler, and a dealer. Who's selling what to whom? Supply and demand mean nothing. People talk and you don't listen. Explicits are unimportant, as they lessen the weight of meaninglessness to the lascivious re-

ductions of gossip. You prefer to engage the in-between, the composite which skews the notion of a constituted majority, questioning it as a vehicle for even that most exalted of daddy voices, the theorist. He hesitantly places his hand on your belly as if he were confronting the gelatinously unpleasant threat of a jellyfish and decrees you a kind of molecular hodgepodge, a desire-breaching minority. You turn to him slowly and say "Goo-goo." He swoons at the absence-like presence of what he calls your naive practices: "the banality of the everyday, the apoliticalness of sexuality, your insignificantly petty wiles, your petty perversions." You are his "asocial universe which refuses to enter into the dialectic of representation" and contradicts utter nothingness and death with only the neutrality of a respirator or a rhythm machine. Goo-goo. But you are not really nothing: more like something not recognized as a thing, which, like the culture that produced it, is an accumulation of death in life. A veritable map and vessel of deterioration which fills your writing like a warm hand slipping into a mitten on a crisp autumn day. And like the exile who asks not "Who am I?" but "Where am I?", the motor of your continuance is exclusion: from desire, from the sound of your own voice, and from the contractual agreements foisted upon you by the law. Order in the court, the monkey wants to speak. He talks so sweet and strong, I have to take a nap. Goo-goo.

1982

Flash Art

Flash Art has asked for a statement in response to a number of questions that they have posed. I'm fortunate they've chosen to include me in their project, as name recognition is the cornerstone of any career, second only, of course, to the visual eloquence of art itself. So how should I begin to respond to this trio of questions: "Why do you make art? What does it mean to be an artist today? What does quality mean to you?" Maybe I should mention that I've also been asked to submit a photograph of myself: a picture of an "artist," an approximation of how I choose to be seen. And since a picture is worth more than a thousand words, perhaps I should begin my "statement" by talking about this picture, this representation of a body, a proper-named identity constructed, in part, through vocation and displayed via photography. Although this picture isn't verbal in the literal sense, it speaks none the less. It joins with other received information about "Barbara Kruger" and works to biographize my body, siphoning out the palpability of incremental moments, laughs, and touches, leaving an outline, a figure which has a life of its own. It "lives" through art objects, journalistic and academic historicizing, visual and textual "mentions," gossip and money. This figure and its production are circulated, categorized, and curated via a system of value that is motored, in part, by the discourse of taste: a fickle compendium of "quality" and "crap," desire and disgust. This figure can be subsumed by fashion as it captures the image of its own perfec-

tion in the hope of being just what someone else is looking for. But it also takes pleasure in displacement, embarrassment, and disarray, in the momentary shut-downs which fill in the figure and allow the body to play (peek-a-boo) with itself: that allow me to get under my own skin and yours. A picture is worth more than a thousand words. "Hi."

1988

Utopia: The promise of Fashion when time stands still

Utopia is at one end of town. Maybe not. At the other end is Fashion. They slowly approach one another. It is high noon and their guns are loaded. In the four minutes in which they have been facing one another, weapons raised, Fashion has changed outfits eight times. He is threatening Utopia, telling her he has promises to keep and moments to guarantee. He says that he wants her and must deliver her to his followers by sundown. She is aware that she has been mentioned. He drops her name, or codes for it, all over town. He proposes a taste of her. He produces desire in and around her. He appropriates her image. He makes all contextual information residue. He engages the physical envelope and dispels lived time. He ignores interiors. He desires lack. He plans and measures it through his production. He is deliberate. Her hands are quick, while his are encumbered by the pushed-up sleeves of his leather jacket. He shoots first and misses. She retaliates. He falters. He's down. He sprawls on the dirt, his jacket stained, his eyelids heavy. He thinks he knows how his face looks now, as taste, unlike other faculties, is able to register its own behavior. Reacting against itself, it recognizes its own lack of taste. She looks down at his body. She is outside of desire. Her gaze moves up his torso and settles on his mouth. She suppresses a grin. His head lolls slowly to the left and then to the right, his eyes roll up, his mouth opens and out of the hole, he greets his desire: "Mr. Death! Mr. Death!"

That was supposed to be an allegory. The idea is not one of ulterior motives because Fashion is an agent from the interior but it doesn't know it and hasn't even been there. The idea is that Utopia and Fashion are like going dutch on a rainy night. That the Utopian promise, the mind's eye of perfection, doesn't even entertain the idea of staying because it knows that Fashion is predicated on acceleration and distraction. Its particularly suggestive hook is the coupling of its aerosolic distribution with its cyclical archaisms, breakdowns, and disappearances. That it dances around the Utopian projection is a clue. It is a tease. A tool. A celebration. A cover. It promises contextual contentment. It hints at a constant ecstasy. It is organized through social production, falls back on the forces of production, and appropriates them. It creates empty spaces.

1979

documenta 7

We are walking through a forest, a fantastic display of all that is awesome and powerful in nature. The sun is golden orange and flushes the azure sky with a warming red glow. We come upon a sparkling pond next to which stands a smoothly hewn marble sculpture. The sun's rays coat the side of the figure, a male nude, classic in its power and assurance. He is gorgeous. An anthem. Behind him is a painting, a masterly depiction of hero-ism rendered with humour and pathos. A picture of brother-hood. A heritage. Through your worshipful response, these objets d'art become much like the insistent sun and soft breezes which caress them: they seem to be nature. But perhaps they are not. Perhaps they are the figures and products of social constructions. We touch your hand softly when we mention this, but you recoil from both our suggestion and our touch. You have an investment in the value of their adoration, in the "nature" of their staying power. Your gaze is devotional. Ours is touristic. Sometimes we hang out in the forest but our rep-resentations strain the appearance of naturalism. We loiter out-side of trade and speech and are obliged to steal language. We are very good mimics. We replicate certain words and pictures and watch them stray from or coincide with your notions of fact and fiction. Like you, we can be charmed by mastery but our pleasures are not defined by connoisseurship. We like to couple the ingratiation of wishful thinking with the criticality of knowing better. We are delighted by the sensuous nature of

the forest and its relative freedom from the constraints of society and architecture. That is what defines its difference from the gorgeous man who stands, sculpted in marble, next to the sparkling pond. We do not wish to destroy what we think is difference.

1982

Work and Money

Whether rendered by hand or caught by a camera, a picture is never opaque. To say that it is, to speak of a mysterious evocativeness, results in just another promotional mystification. We see an image and we start guessing meanings. We can embroider stories or supposed narratives. Photography's ability to replicate, its suggestion of evidence and claim to "truth" point to its problematic powers but also suggest a secular art which can connect the allowances of anthropology with the intimacies of a cottage industry. It is a trace of both action and comment. In my work I try to question the seemingly natural appearance of images through the textual commentary which accompanies them. This work doesn't suggest contemplation: it initially appears forthright and accessible. Its commentary is both implicit and explicit, engaging questions of definition, power, expectation, and sexual difference. Some of us, with one or two feet in the "art world," might think that our work is all cut out for us, while others are interested in changing the pattern and defining different procedures. Many of us also work in areas outside of our art production. Whether out of necessity or adventure, we are at the same time secretaries, paste-up people, billing clerks, carpenters, and teachers. At times our jobs inform our work and visa versa. For instance, teaching, which is a collective process within the hierarchies of education and academia, intervenes in the production of cultural work. Art schools reproduce artists and, in turn, art. It's all work. And most people work for

money. But unlike laborers who sell moments of their lives for a short reprieve at the end (the awaited or dreaded retirement), artists buy work time with job money. Of course, whether this routine is really necessary depends on the good or bad fortune of your fortune: whether you must really work for your money or are merely waiting to inherit it. Money talks. It starts rumors about careers and complicity and speaks of the tragedies and triumphs of our social lives. It makes art. It determines who we fuck and where we do it, what food we eat, whether we are cured or die, and what kind of shoes we wear. On both an emotional and economic level, images can make us rich or poor. I'm interested in work which addresses that power and engages both our criticality and our dreams of affirmation.

1981

Incorrect

Photography has saturated us as spectators from its inception amidst a mingling of laboratorial pursuits and magic acts to its current status as propagator of convention, cultural commodity, and global hobby. Images are made palpable, ironed flat by technology and, in turn, dictate the seemingly real through the representative. And it is this representative, through its appearance and cultural circulation, that detonates issues and raises questions. Is it possible to construct a way of looking which welcomes the presence of pleasure and escapes the deceptions of desire? How do we, as women and as artists, navigate through the marketplace that constructs and contains us? I see my work as a series of attempts to ruin certain representations and to welcome a female spectator into the audience of men. If this work is considered "incorrect," all the better, for my attempts aim to undermine that singular pontificating male voiceover which "correctly" instructs our pleasures and histories or lack of them. I am wary of the seriousness and confidence of knowledge. I am concerned with who speaks and who is silent: with what is seen and what is not. I think about inclusions and multiplicities, not oppositions, binary indictments, and warfare. I'm not concerned with pitting morality against immorality, as "morality" can be seen as a compendium of allowances inscribed within patriarchy, within its repertoire of postures and legalities. But then, of course, there's really no "within" patriarchy because there's certainly no "without" patriarchy. I am

interested in works that address these material conditions of our lives: that recognize the uses and abuses of power on both an intimate and global level. I want to speak, show, see, and hear outrageously astute questions and comments. I want to be on the sides of pleasure and laughter and to disrupt the dour certainties of pictures, property, and power.

1982

Picturing "Greatness"

The pictures that line the walls of this room are photographs of mostly famous artists, most of whom are dead. Though many of these images exude a kind of well-tailored gentility, others feature the artist as a star-crossed Houdini with a beret on, a kooky middleman between God and the public. Vibrating with inspiration yet implacably well behaved, visceral yet oozing with all manner of refinement, almost all are male and almost all are white. These images of artistic "greatness" are from the collection of this museum. As we tend to become who we are through a dense crush of allowances and denials, inclusions and absences, we can begin to see how approval is accorded through the languages of "greatness," that heady brew concocted with a slice of visual pleasure, a pinch of connoisseurship, a mention of myth, and a dollop of money. But these images can also suggest how we are seduced into the world of appearances, into a pose of who we are and who we aren't. They can show us how vocation is ambushed by cliché and snapped into stereotype by the camera, and how photography freezes moments, creates prominence, and makes history.

1988

Repeat After Me

That doubt tempers belief with sanity. That "we" are not right and "the enemy" wrong. That it's a good idea to remain self-critical when power is near. That God is not on our side. That all violence is the illustration of a pathetic stereotype. That the notion of "human rights" should include the oppression of women. That it's important to vigilantly look for the moment when pride becomes contempt. That TV and print journalists should begin to acknowledge and understand their ability to create consensus and make history. That certain terms are long overdue for examination and clarification. That it's time to question what is meant by the words "moral," "normal," "manhood," "community," "standards," "drawing the line," "values," "political," "objectivity," "agit-prop," "avant-garde," and the prefix "post" in front of anything. That the issues of money, sex, power, and racial difference are inseparable from one another. That the richness and complexity of theory should periodically break through the moats of academia and enter the public discourse via a kind of powerfully pleasurable language of pictures, words, sounds, and structures. That empathy can change the world. That feminisms suggest many ways to live a life and that they continue to question both the conventional arrangements of power and the clichés of binary oppositions. That there should begin to emerge in America a kind of secular intellectual who can fight the fear of ideas with clarity, generosity, humor, and eloquence.

1992

American Manhood

I've been asked to comment on the state of American manhood. But what is this "American Manhood"? Is it a single category that contains all the attributes of both manhood and Americanness? Is it a kind of rangy, all-encompassing universality: a "big-tent" sheltering all the conventions of masculinity? It seems to me that there's a big difference between being a man and belonging to a manhood. And this difference bears some scrutiny.

"Man" can denote gender. It can be a signifier of biological phylum based on the investigations of science and the shifting identities of the body. But "Manhood," well, that's another story. It's about society, stereotype, myth, folklore, power, and, of course, ideology. "Man" can be nature but "Manhood" is culture. Being a man can be about pleasure but belonging to a manhood is usually about desire. Which is kind of sad because desire only exists where pleasure is absent. Manhood is what you're supposed to want.

And with that in mind, I realize that *Esquire*'s asking me to comment on "Manhood" really makes a lot of sense. After all, magazines are, to a large degree, about desires and images of perfection. They feed us the "latest model," they show us "the look" and tell us how to get it. And because they are extremely temporal creatures, magazines know that today's divinities are yesterday's papers. They want interchangeable figures, not bodies. They want "Manhood" and not "Man." Of course, maga-

zines can also be about meatier stuff: brow-furrowing think pieces and journalistic tacklings of tough questions. But all this seriousness is brought to you by about two hundred pages of advertising and *that's* where we're really told about manhood, about how it looks and what it takes. It might be hunky, or quirkily reticent, or exhilaratingly bohemian. It can be heroic or self-conscious, black or white, straight or gay, zany or serious, casual or formal. "Manhood" is "Man At His Best" and very good for business.

1991

Not Funny

If you think there's a long stretch of unoccupied emotion between laughter and sorrow, then think again. Because the two are linked in a messy tango of slippages, mixed messages, and quadruple entendres. Demanding a commentary that vigilantly patrols the dicey terrain between vulnerability and meglomania, arrogance and abjection, the comedic is motored by its intimacy with objectification, by its ability to step outside of it all and still get under its own skin. This produces a kind of pathos, a well-choreographed ritual of jokey self-humiliation that reaches both its apex and nadir in the stand-up form, with its proscenium positioning and static, direct address. From its predictable kvetching to its emblematic farewell (the by now mega-Vegasized "Thanks guys, you've been terrific"), the stand-up genre is less cogent as content than as an excruciatingly tragic form of roteness: a formality yielding few laughs but capable of puking up volumes about the devolution of ironic commentary from powerfully poignant eloquence to vacuous schtick.

Planted in front of the inevitable brick walls of innumerable comedy clubs, mouthing off on scads of network talk shows and cable specials, these practitioners constitute an army of insistently frantic yucksters whose ineptitude makes the possibility of good material recede like a meekly retreating hairline. But it's a sad reminder of the tenor of our times that no matter how inept and pathetic, no matter how desperate and driven, these performers can't hold a candle to the delusionary zeal,

weird presentational styles, and comic intensity of some of our public officials, the politicians that we're daft or brain dead enough to vote into office. After all, what performer comes close to delivering the laughter provided by our Vice President: by his comedically mesmerizing ineptitude, by his eyes glazed over by blissfully undisturbed delusions, by his ego construction, so brazenly unencumbered by reality testing? He takes us to another place in time, an almost existential realm where we've cast our fate to the wind in a chill world. But while comedy is defined in part by its investment in commentary, by its parodic relationship to lived experience, the laughter elicited by Dan Quayle's ridiculousness is tinged by the terrifying fact that there is no pun intended: what rivets us is not the ironic distancing of an examined life but the fascinating arrogance of stupidity.

1990

Irony/Passion

You are reading this and deciding whether it is irony or passion

You think it is irony

You think it is exercising a distancing mechanism

You think you can escape codification

You can't

You don't belabor the point, because you know that irony is
 rife with forgiveness

You are lucky this isn't passion, because passion never forgets

You only employ the declarative in a parodistic context

You neutralize information through display

You do what you can to get what you want

You know how to locate and stroke a tendency

You are aware of obligatory concerns

You are a child of inheritance but prefer not to discuss it

You sometimes like to act like you're not a professional

You live in a bad neighborhood but it feels good to you

You think violence provides interesting visual and textual
 material

You bypass the correlations between sexuality, calls to arms,
 race, property, style, fear, duty, authority, and power

You are aware that saying, naming, and pointing are the
 handiest forms of appropriation

1979

Untitled

If this is Utopia, no wonder nothing is real. Enveloped by a circulatory loop of scenes, we move but remain stationary, as befits any sometimes well-meaning site of receivership. We become hazy, fugitive shapings surrounded by shiny, well-defined goods and services which display themselves to us, offer themselves up to us, implore us with a rhythm of their own. A rhythm beyond biological imperatives, beyond the vulnerabilities of heartbeats, beyond the incision-prone vagaries of skin. And although we are aware of our miniaturized and stilled positionings, although sometimes it just hurts so good, we will continue insistently to ruin things a bit: to drag the sheet off the ghost in the out-moded machine and pull the plug on a few major league games. Uninterested in the romantically ineffectual narratives of subversion, we take off our trench coats, come in from the cold, and quickly change the station. We keep one eye on the sadly predictable strategies of declaration, another on the tired militarism of binary oppositions, and another on the mopey challenges of disinherited subjects. We can be amused by ardent attempts to locate good and evil in the citizenry and realize how the construction of current events is that of conventional narrative fiction. We agree that truth has been splintered into an aerosol of demi-articulate self-interest which recomposes not into language, but into pictures. And although you continue to picture us, we have no desire to picture you. No desire to merely reverse positions and gel into gloomy

authoritarian mimicry. No desire to appropriate your subjectivity only to sell you short into some seriously stunned objecthood. We are made sleepy and not just a little numb by rhetorical flourishes which signal a mania for categorizations: good and evil, seen and unseen, offense and defense, cops and robbers. And oh, it turns us silly to recount the innumerable skirmishes danced around the outmoded mechanics of desire, and leaves us, how shall I say, distracted. We take our pleasures far from the dissatisfactions of judging, producing, measuring, progressing, and yenning. We tend to visit various sites on the sometimes horizontal scrim which spans the distance between the cartoons of emancipation and possession. Preferring reception to submission, we are made giddy by the possibility of a fluid mingling of once subjects with once objects. We will not mourn the passing of self-deluded naivetés, but refuse the job of quality controller, exiling this or that into the humiliated kingdoms of "the naive," "the vulgar," and "the banal." We decline the mantle of morality, as the notions of the moral and the ethical are due for a degree of ventilation, a sabbatical from their thrones of surety and cognition. Instead, we seek out the possibilities of a benevolence and plenitude which rejoices in a kind of juicy, celebratory tolerance. And while a generous dollop of non-specificity gives us room to circulate, we needn't construct a world for others, a censorious image of our own (im)perfection. Resisting the stereotypes of both offense and defense, we realize that the former tends to entail endless hours of bodybuilding, while the latter can seem open-wounded, glum, and paranoid. Besides, nothing upsets the game more than a change in the rules. Opting for the living room rather

than the stadium, we forego the spectacular long shot for the slices of the close-up. Shredded totalities go the way of highly classified documents which disappear and take their secrets with them. Maybe. The linear document becomes archaic, worth no more than the paper it's printed on. And paper itself, once the tray of language, has relinquished its role and has been run out of town by gangs of waves, lights, and transmissions: a pervasive electronic universalization which produces a closure so broad that it almost seems full of openings. But it appears to be sealed tight, pretty much impervious to leakage and with little allowance for reciprocity. We remain semi-alert to its incremental alterations, glued like kitties transfixed by mouse-like movements. And while we watch but do not see, histories are evacuated and deposited into memory banks where all will soon be forgotten. To remember becomes an embarrassment; the image upholds its reign of fascination, but strangely, something else may still be stirring. Something located between theory, laughter, and the concretion of things. Something which has benefited from the dispensations of the long shot, which appreciates the prophesies of science fiction and yet is disappointed by a deluded solidarity drenched in ineffectiveness. Something which foregoes a singular strategy for a series of simultaneous games, which indulges in a laughter located nowhere near contempt and tries to communicate without the belligerence of the challenge. Something which has no need for utopias or sacred structures of belief, and finds power's disingenuous attempts at invisibility and self-effacement to be as predictable as a not so hot rerun. Something which can materialize from fluids and vapors and then disappear back into the ground. Something of

a body, a fleshy concretion capable of a bit more than just petty wiles. Something sometimes not recognized as a thing, which, like the culture that produced it, can be an accumulation of death in life. But this living end can be just the beginning. This could be the start of something big or small, which can cutely (or perhaps to you, suspiciously) dodge and play with the formalities of power: fouling up its etiquette, giving it a run for its money, getting it all hot and bothered, and then simply choosing to sit out the game.

1987

Job Description

Your *work* is about
the frame and the confines of articulated space
the edge and the tension of a peripheral locator
color and the signature of saturation
light and the creation of the illusory site
surface and the dictates of the forearm
placement and the expository ground
formula and the elegant solution
decor and the belated recognition of the practical arts
material and the physical embrace
figures and the rhetoric of the real
structure and the puncture of space
buildings and the direction of task
dislocation and the subversion of the habitual
the arena and the business of men
opacity and the exhaustion of social life
desire and the prolongation of stasis
shopping and the image of perfection
utopia and the abandonment of context
sex and the collapse of the closet
commentary and the announcement of the additional
audience and the scrutiny of women
visual splicing and the resonance of the cut
naming and loosened singularities
transparency and the desire for rest

voyeurism and the long shot

hooliganism and the lure of the picaresque

privilege and the tyranny of exclusion

fashion and the imperialism of garments

broadcast and the short conversation

narrative and the gathering of incidents

dreams and the sliding of meaning

memory and the defeat of total recall

trauma and the sound that only dogs can hear

disease and the accumulation of profit

property and the feel of value

race and the fear of difference

money and the velocity of power

analysis and the maintenance of the laboratory

neutrality and the dealing of the double

argument and hand to hand combat

language and the rubbing of skin

quotation and the rhythm of stacked bodies

pleasure and the proper name

1984

Credits

Arts and Leisures
"Arts and Leisures." *New York Times,* September 9, 1990.

"Quality." Written for a symposium on "Quality: Form and Content in Contemporary Art," The Richard and Marieluise Black Center, Bard College, June 3, 1991.

"Remaking History." In *Remaking History,* ed. Barbara Kruger and Philomena Mariani. New York: Dia Art Foundation; Seattle: Bay Press, 1989.

"An 'Unsightly' Site." Assigned by the *New York Times,* op-ed page, July 1988. Unpublished.

"Contempt and Adoration." *Village Voice,* May 5, 1987.

"Prick Up Your Ears." *Esquire,* May 1992.

TV Guides
The essays in this section were all published in *Artforum* in a column entitled "Remote Control," with the exception of the last two essays, the first of which appeared in the October 1979 issue of *Real Life Magazine* under the title "Game Show." The last essay in this section, "Remote Control," is a film treatment written in 1985.

Moving Pictures
The reviews in this section were published in *Artforum,* with the following exceptions:

The review of *The Trap Door* (directed by Beth B. and Scott B.), written in 1979, first appeared in *Ideolects: Film Journal of the Collective for Independent Cinema,* no. 9–10, 1979.

"Frank Tashlin" was written in 1979 and has not been previously published.

Position Papers

"Not Nothing." *ZG*, 1982. Reprinted in *Discussions in Contemporary Culture*. New York: Dia Art Foundation, 1987.

"Flash Art." *Flash Art*, November–December 1988.

"Utopia: The promise of Fashion when time stands still" (1979). In *Just Another Asshole*, ed. Barbara Ess and Glenn Branca. New York: Just Another Asshole, 1983.

"Work and Money." Statement for a panel at the School of Visual Arts, New York, 1981.

"Incorrect." *Effects*, 1983.

"documenta 7." Catalogue statement, documenta 7, Kassel, 1982.

"Picturing 'Greatness.'" Wall text for exhibition at the Museum of Modern Art, New York, January 1988.

"Repeat After Me" has not been previously published.

"American Manhood." *Esquire*, October 1991.

"Not Funny" has not been previously published.

"Irony/Passion." *Cover*, vol. 1, no. 1, May 1979.

"Untitled." Catalogue essay for an exhibition at the Mary Boone Gallery, May 1987.

"Job Description" was first published in 1985.

Index

Absence, 5, 9, 172, 222, 224. *See also* Objectification
 of women, 105, 211
Ackerman, Chantal
 The Golden Eighties, 185–187
 Jeanne Dielman, 23 Quai du Commerce, 1080 Bruxelles, 187, 199
 Je, Tu, Il, Elle, 165–166
 Les Rendez-vous D'Anna, 187
 Toute Une Nuit, 186
Ackroyd, Dan, 194
Akomfrah, John, *Handsworth Songs,* 119–120
Allori, Cristofano, *Giuditta,* 177
Altman, Robert, *Streamers,* 185
Amazing Stories, 71
American Pictures, 121–124
Andreas-Salomé, Lou, 125–127
 works of, 125
Anorexia nervosa, 159–162
A Nos Amours, 148, 150–151
Antonioni, Michaelangelo, *Identificazione di una Donna,* 104, 105–106
Artists and Models, 203
Assholes, 25, 57

B., Beth and Scott, *The Trap Door,* 196–198
Bakker, Jim, 45
Balint, Eszter, 149
Barker, Bob, 94
Barry, Judith, works of, 142–144
 "Casual Imagination," 144
 Casual Shopper, 142–144
Baudelaire, Charles, 112
Beatt, Cynthia, *Fury Is a Feeling Too,* 179–180
Bedelia, Bonnie, 188
Benjamin, Walter, *Baudelaire,* 142
Bernhard, Sandra, 6